IMAGES
of America

CLAYTON

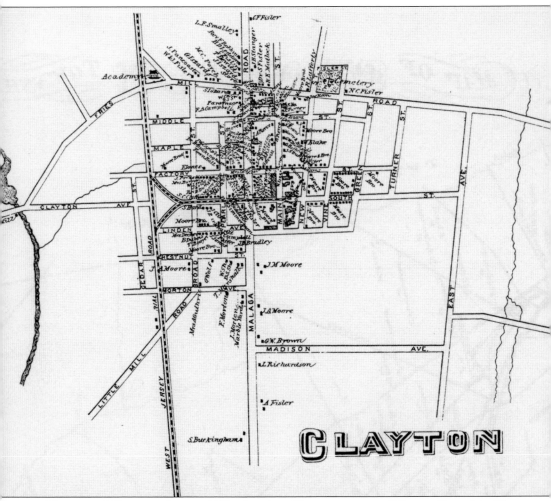

This map of Clayton is from an 1876 atlas when Clayton was part of Clayton Township. The map includes the names of homeowners as well as the types of businesses that occupied the buildings. A larger, readable copy is located at the Clayton Historical Museum. (Courtesy Clayton Historical Preservation, Inc.)

ON THE COVER: This photograph of the old town hall was taken in the early 1950s when the building was no longer used as the town hall. At the time of this photograph, it was an antique shop owned by the Glick family. (Courtesy of Daniel Ferrell.)

CLAYTON

Christopher Gassler
and Clayton Historic Preservation

ARCADIA
PUBLISHING

Published by Arcadia Publishing
Charleston, South Carolina

Printed in the United States of America

Library of Congress Control Number: 2010925933

For all general information, please contact Arcadia Publishing:
Telephone 843-853-2070
Fax 843-853-0044
E-mail sales@arcadiapublishing.com
For customer service and orders:
Toll-Free 1-888-313-2665

Visit us on the Internet at www.arcadiapublishing.com

To the residents of Clayton, past and present, this book is for you.

CONTENTS

ACKNOWLEDGMENTS

Since the Clayton Historic Preservation was founded in 1989, volunteers have given countless hours preserving the history of Clayton. It would have been impossible to complete this project without their hard work and love of our town. I would like to thank Jeff Field for being a constant source of information when I needed facts clarified and pictures identified. I would also like to thank all the current members of the Clayton Historic Preservation: Glenn Kindle, Ruth Cassaday, Jean Schoelkopf, Jeff Radio, Edmund Field, Ed Reimer, Betty Abdill, Phil Gilson, Daniel Ferrell, June Salvatore, and Thomas Perini, as well as past members of the preservation. Your love for our hometown is contained within the pages of this book. Unless otherwise noted, all images appearing in this book were graciously provided by the Clayton Historical Museum.

INTRODUCTION

Clayton's history is a rich and exciting story filled with the same American spirit that formed this country when it was inaugurating. Clayton's roots began how most stories of American small towns begin: with a family of immigrants. In 1730, Felix Fisler, along with his wife, Barbara, two sons Jacob and Leonard, and two daughters Usley and Elizabeth, left their home in Suisenlin, Switzerland, and booked passage on a ship headed for the New World. Aboard the same ship were Sophia Klein and her parents. When the captain of the ship had Sophia's parents killed for their money, Felix Fisler paid the fare for Sophia so she would not be sold as chattel when the ship docked. Sophia then became associated with the family, and 14 years later, Sophia married Jacob Fisler, Felix's son.

After their wedding, Jacob and Sophia Fisler settled near Swedesboro, New Jersey. They lived along the banks of the Delaware River and raised 11 children. During the Revolutionary War, the family fell victim when British soldiers stole the Fislers' cattle and even took some of their younger sons as servants. Jacob eventually purchased 2,800 acres of land near the present Cedar Green Cemetery in Clayton, built a home, and moved inland with his family and their possessions.

Three of the Fislers' sons—Felix, Jacob Jr., and Leonard—served in the army during the Revolutionary War. In addition to the family's first cabin, a second cabin was built where Jacob and his sons would stay when coming home from war. At the time, the town where the second cabin was located consisted of five homes, all located on the land between the Malaga Turnpike (now Delsea Drive), Route 47, and the "Road to Fries' Mill" or "Road to Fislers' Mill," which is now named Academy Street. The crossroads were known as Fisler Town.

After the Revolutionary War, Jacob and his son Leonard jointly bought 3,755 acres, expanding Fisler territory from the land near the Clayton cemetery westward to Aura. Leonard built a home on this new land by Still Run Creek, which is now called Silver Lake. Jacob's younger sons moved to the land west of Still Run. The family also owned the land eastward of the cemetery to Fries' Mill and had a homestead next to the lake.

As their territory expanded in size, it also grew in population. More and more families moved to the area, and by 1812, thirty-six families had settled in Fisler Town. Jacob Fisler, now a doctor, donated 4 acres to be used for a facility that would serve as a school by day and a meetinghouse for religious and civic gatherings in the evenings. This new building was called the Useful School House and housed the Methodist church meeting until a church was erected.

In 1847, Francis Wilson bought 1,600 acres of land, which he named Fries' Mill for himself and some other farmers. On his newly purchased land, a sawmill was built, along with a bridge over the stream. A corduroy road, or "pole road," was built to connect Fries' Mill with Fisler Town. In addition to his farm and the sawmill, Wilson also had a store located in this area. He opened up his home to be used as a school during the day, a place for prayer meetings every Friday night, and a location for Presbyterian church services on Sunday mornings. Eventually a small schoolhouse was built in the vicinity. The lake located by Wilson's farm was renamed Wilson Lake in his honor.

With growth comes change, and in 1850, the name Fisler Town was altered to Fislerville. In addition to the name change, there was another transformation in town that shaped the community for years to come: Fislerville Glassworks was built by Dr. Jacob Fisler and Benjamin Beckett, which prompted exponential growth in this tiny town. In 1851, Edmund P. Bacon bought Beckett's shares of the business, but in 1855 Bacon was killed in a train accident. In time, the glassworks went into foreclosure and the business was sold to John M. Moore, who, at the time, had rented buildings from Fisler. Later Moore's brother, D. W. Moore, joined him as a partner in the business. The Moore brothers' glass factory was well known and its workers continued successfully blowing glass until 1911, when hard times took glassblowing westward.

John Moore owned a considerable amount of land around Fislerville on which he laid roads leading from town to the outskirts, specifically to the farms that he rented. During slack times at the glass factory, Moore kept his workers busy by having them clear and prepare the land for roads. He also bought Fisler and Harding Pond—later renamed Moore's Lake and now called Silver Lake—located on the west side of town. Moore was very instrumental in the growth and upkeep of Fislerville during these booming years.

In 1858, Fislerville became a part of Clayton Township, which also contained the towns of Glassboro and Aura. In 1860, the West Jersey Railroad was built from Millville to Clayton Township. In 1862, Fislerville changed names again, now called Clayton for Clayton Township. The origin of the name Clayton is still a mystery. Some say it is derivative from the white clay deposits found around the town, others say it is named after the Clayton family, whose daughter Hannah married Col. Charles Heston of Revolutionary War fame. By the later half of the 19th century, Clayton was regarded as one of the most affluent towns in south Jersey.

Clayton continued to grow and birthed a number of businesses that employed the local population. Silver and Chamberlain Brush Factory started there and quickly grew in size, shipping brushes across the country. Hungerford and Terry, Inc., a water purification company known for doing business worldwide, also found its roots in Clayton and was successful for many years. Throughout its history of progress and development, Clayton still maintains its sense of pride and spirit, which helped shape it from the beginning.

One

THEY BLEW GLASS

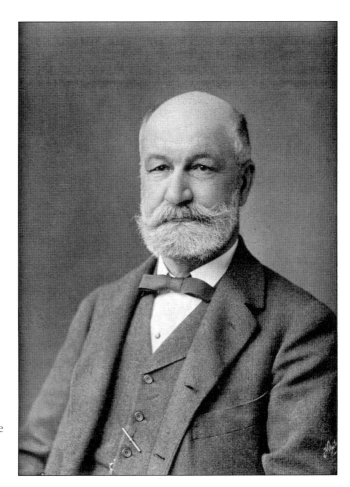

John Mayhew Moore was born January 1, 1827. In 1856, he purchased Fislerville Glassworks. He spent the following four years revitalizing the business, buying new land, and acquiring new accounts. In the 1860s, the business expanded and he changed the name to J. M. Moore and Company.

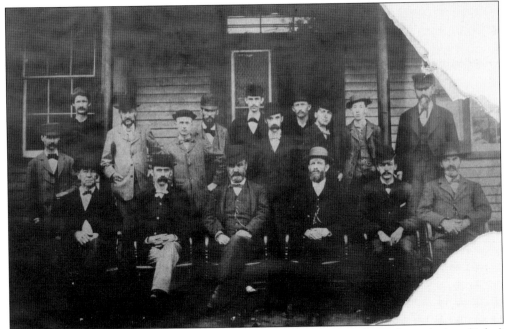

John Moore (seated center) is pictured here with his brother D. Wilson Moore (right of John) and Franklin Pierce (right of Wilson). John and Wilson invested their time in the design and development of Clayton, which became known as the "best planned town in south Jersey." Their money was spent on the construction of tremendous churches and fantastic mansions that are remembered as landmarks of their time.

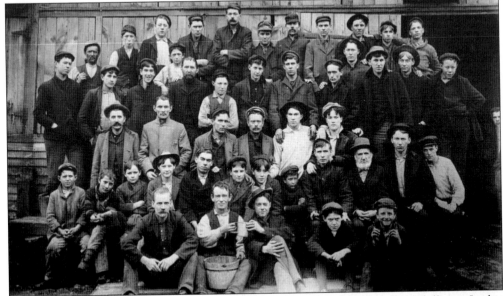

In 1866, Clayton (then Fislerville), had three factories fully staffed with workers of all ages. In this photograph of the Moore brothers' glass factory, many of the workers are boys. There were several men, 16 years old and younger, who were employed at the business. They learned the trade of glassblowing during their early years since it was a popular source of employment in south Jersey due to the availability of glass sand.

While the glassworker's job was a grueling one, it seems John Moore was a generous employer. In 1869, employees at the glass factories were rewarded with a day in the sun. Each worker was given a free excursion to Cape May. Since Atlantic City was not yet developed, Cape May was a popular shore stop of the day.

Workers pictured here were part of a strike in 1886 that involved many glassblowers in south Jersey. It was organized by the Knights of Labor, but the workers of Clayton apparently took matters into their own hands and returned to work on their own.

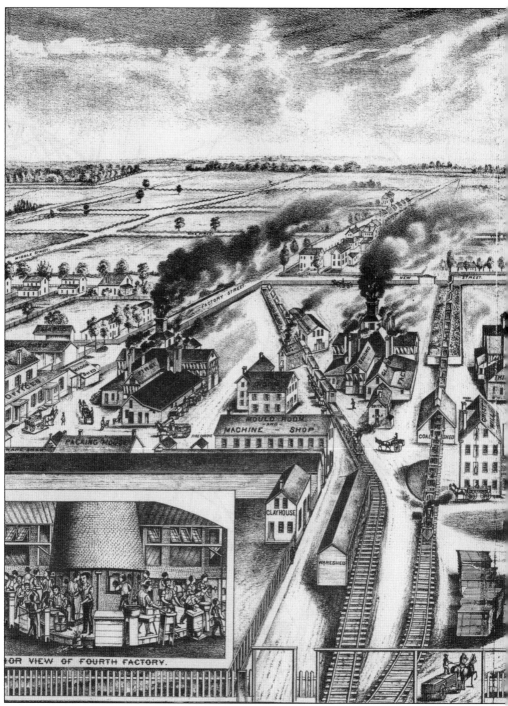

The glassworks operation was the heart and soul of Clayton, which was described as a town covering 15 acres with four large glass factories. Included were a gristmill, sawmill, machine shop,

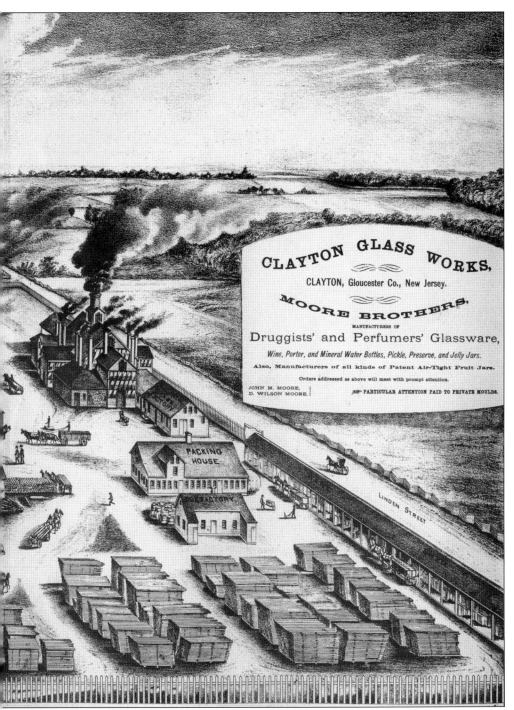

CLAYTON GLASS WORKS,

CLAYTON, Gloucester Co., New Jersey.

MOORE BROTHERS,

MANUFACTURERS OF

Druggists' and Perfumers' Glassware,

Wine, Porter, and Mineral Water Bottles, Pickle, Preserve, and Jelly Jars.

Also, Manufacturers of all kinds of Patent Air-Tight Fruit Jars.

Orders addressed as above will meet with prompt attention.

JOHN M. MOORE,
D. WILSON MOORE.

PARTICULAR ATTENTION PAID TO PRIVATE MOULDS.

a railroad that ran throughout the property, and every necessary auxiliary to one of the most extensive and best arranged glasswork factories in the union.

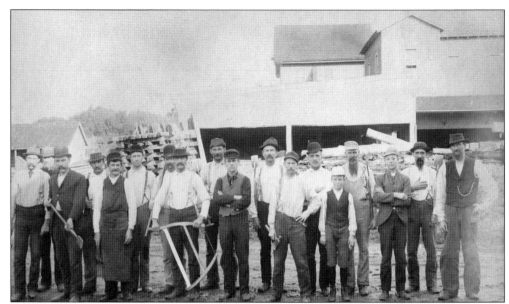

The Moore brothers frequently gave back to their community. They often employed men to perform unnecessary work on their farm, providing employment to those who had trouble finding it. During the toughest days of the Civil War, the Moores distributed 100 pounds of flour to each employee to help with basic necessities, and they were also known to have helped keep the town looking pristine by paying homeowners $10 to paint their homes.

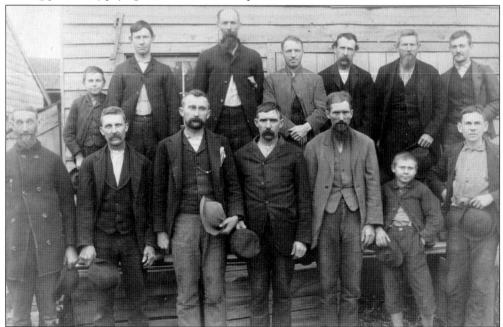

After the strike in 1886, the glassblowers were back in full swing and life in Clayton began to return to usual. Unfortunately, this normalcy was short-lived because John Moore passed away June 1, 1901. His funeral was a major event with area politicians, New Jersey's governor, local judges, and glass factory workers in attendance. A special train schedule had to be arranged to bring people to the funeral service.

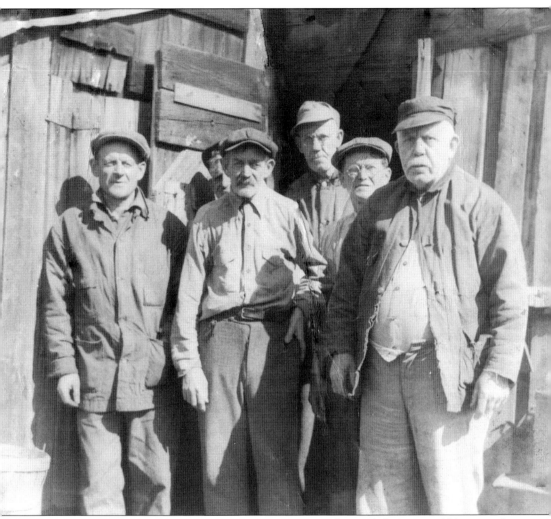

When the Moore brothers closed their factory in 1912, a new glasswork factory would be started by William Henry Clevenger, pictured above at far left. He was a "master glass shearer" or a "window glass worker" who came to work for the Moore brothers in 1890. He moved his wife and four sons into a "Moore brothers house" on Linden and Vine Streets, which was built for Moore brothers' factory workers.

Note how simple the Clevenger Glass Factory was. Clevenger's son George died of heart-related problems when he was 21 years old. Clevenger's remaining three sons were taught the skills of glassmaking at the Moore brothers' factory; Thomas was apprenticed in 1895, Lorenzo (nicknamed "Reno") in 1900, and William (also called "Allie") in 1901. Although D. W. Moore strived to keep the factory alive after his brother's death, the factory closed in 1912 and the Clevenger brothers needed to find work elsewhere.

Pictured is another view of the Clevenger Glass Factory. Before it grew to be this, the three Clevenger brothers operated a small rug factory that they built in a shed in their backyard. They were successful and became well known for their high-quality rugs. However, the effects of the Depression left the brothers without enough demand to support the business. Times were especially hard for Thomas, who had 10 children to feed.

Given their knowledge of glassblowing, the brothers decided to try their hand running their own glasswork operation. Since they had very little money to start with, the Clevengers rummaged through the Moore brothers' buildings for mortar and brick to help construct a furnace in the stable of their backyard on Linden and Vine Streets.

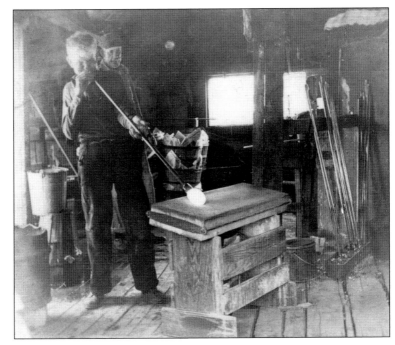

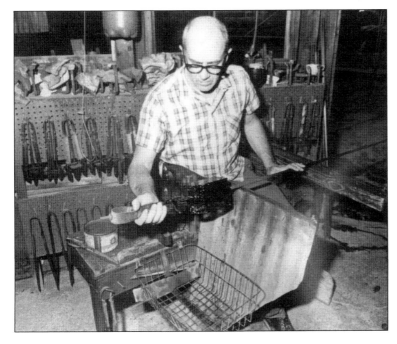

The Clevengers' first glassblowing endeavors did not produce the best results, but with time, patience, and practice they improved immensely. They sold glassware from a building in their backyard, located on Vine Street. Sales were slow, so most of the money went to Thomas, given the size of his family. The other brothers found outside work to augment their income and keep the factory running.

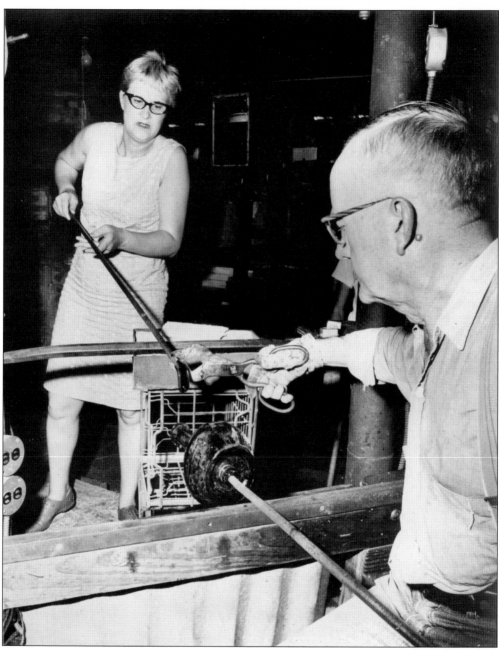

Mrs. James Travis was one of the few women to handle the long blowpipes. Thomas Clevenger died in 1934, leaving his brothers to run the factory. The business began to change and wooden molds came into use. When the surviving two brothers began using these types of molds, production began to increase.

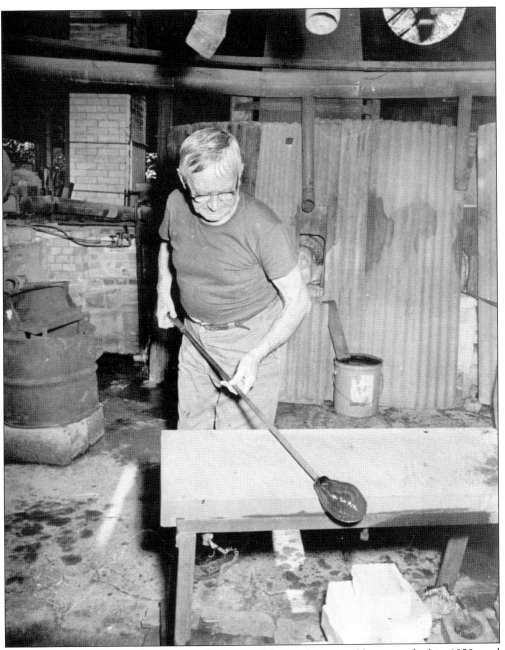

In the 1950s, business endured some changes and losses. Lorenzo Clevenger died in 1950, and a fire destroyed part of the building in 1957. In 1958, a larger structure was erected in its place and glassblowing resumed. Then William Clevenger died in 1960, leaving his wife, Myrtle, with the help of Stout Bowers, to run the business. They operated the business under the name Clevenger Brothers Glass Works since the brothers' name had become synonymous with the industry in Clayton.

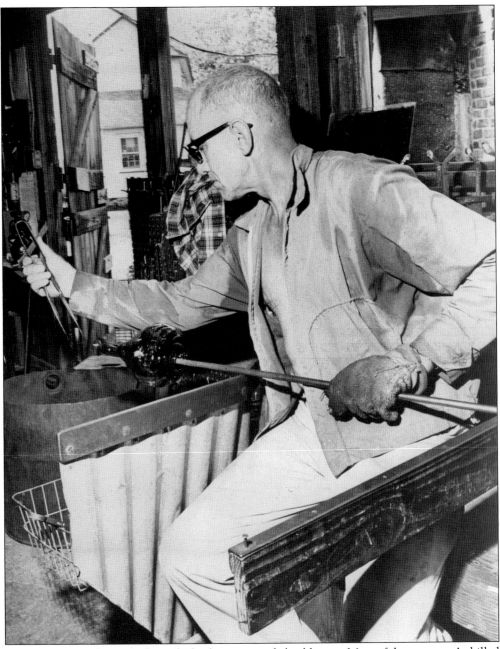

The factory closed in 1964 due to lack of experienced glassblowers. Most of the company's skilled craftsmen were elderly, some upward of 80 years old. When they were no longer able to work, Clevenger Brothers Glass Works went up for sale.

In 1966, James Travis came to Clayton from Millville looking to purchase some of the Clevenger molds. He ended up buying the entire glass factory. He, his wife, and son worked in the factory, which still operated under the name Clevenger Brothers Glass Works. Travis added new items, the most lucrative being the glass garden balls, also called gazing balls, which were shipped all across the country.

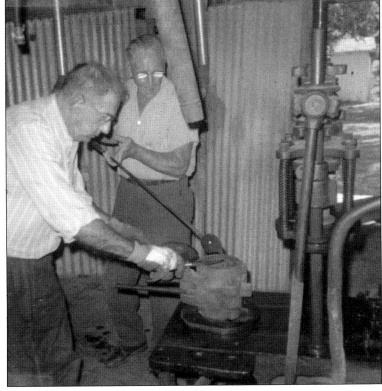

As time went on, the factory continued to struggle with finding experienced workers. Travis advertised jobs for glassblowers all across the country, but his efforts were all for not. The Clevenger Brothers Glass Works closed its doors again.

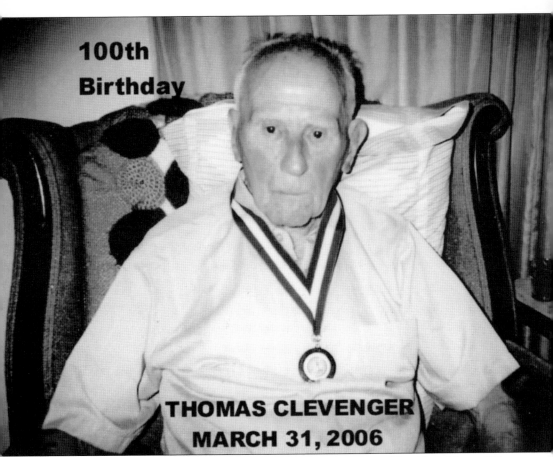

100th Birthday

THOMAS CLEVENGER
MARCH 31, 2006

Thomas Clevenger Jr. lived to the ripe old age of 100. He was one of the 10 children of Thomas Clevenger Sr., who was the oldest of four brothers.

Two

SCHOOLS

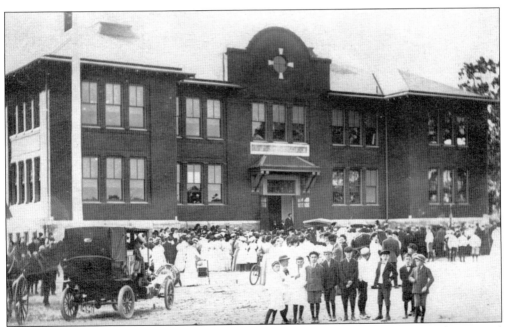

Pictured here is opening day of the Academy Street School on September 18, 1908. This original school cost $40,000 and was constructed to replace a smaller two-room schoolhouse built on the same piece of land in 1883. This three-story building was designed to include primary through high school grades. It was Clayton's first high school.

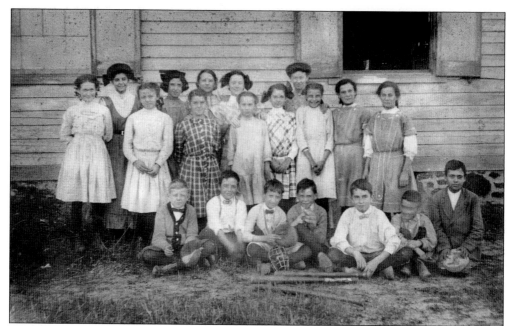

This class is pictured in front of one of many two-room schoolhouses that were used before the Academy Street School was constructed. These buildings were no bigger than a two-car garage. This school was used to teach students during the day and to house religious services in the evenings until 1850, when Clayton's first church was built.

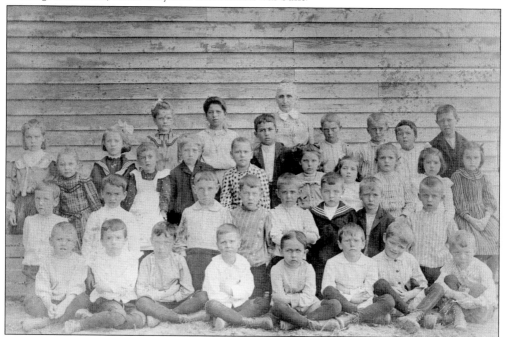

Another class is pictured in front of an old two-room schoolhouse. Along with the schoolhouse on Academy Street, one was located by Wilson Lake and another on the corner of Academy Street and Main Street. The latter school, moved to Delsea Drive, is presently the building occupied by Dancing By Denise.

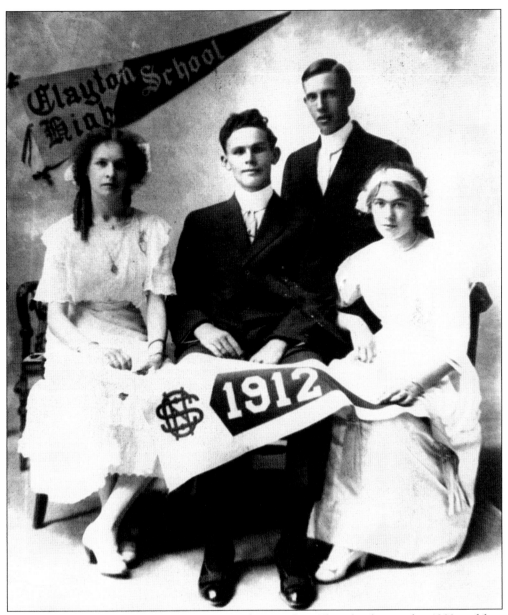

Pictured here is Clayton High School's first graduating class. The school opened in 1909, and four years later these four students were the first to graduate from it. Members of the class of 1912 are, from left to right, Madeline Ewan, Milford Peterson, Luther Miller, and Lillian Peterson.

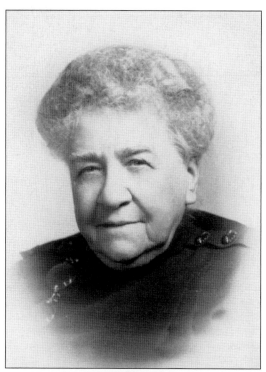

Remembered fondly, though she was a disciplinarian, is Nana E. Haupt. She was a math teacher who became the first principal of the new Clayton High School. Many students remember how she would shake her keys to warn students she was coming so they would straighten up and act properly. The local football field was given her name in honor of her service to the students of Clayton High School.

Given the Academy Street School was not originally built with an auditorium, the school would hold graduations in the local Methodist-Episcopal Church. Pictured here, inside the church, is the graduating class of 1916. The students, in no particular order, are Richard Ewan, Esther Nickelson, Donald MacGregor, Charles Beckett, Kathryn Plum, Gertrude Sutch, Beatrice Beckett, Hazel Hangerman, Grace Malton, Louise Ernest, and Doris Williams.

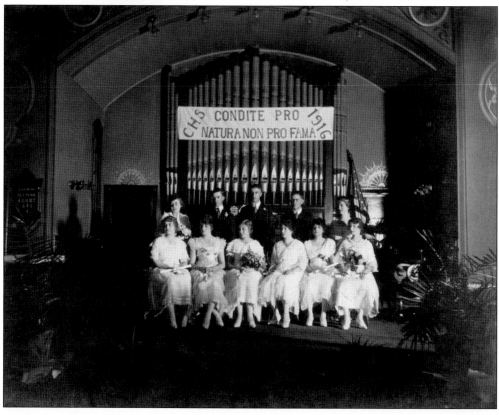

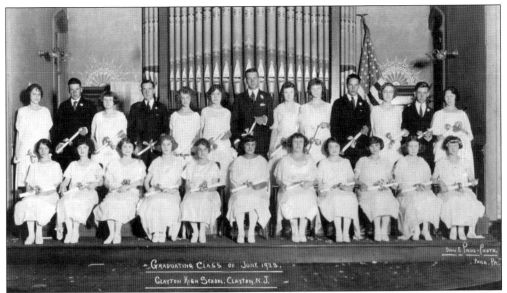

Here is another class graduating in the Methodist-Episcopal Church. The members of the 1923 graduating class are, from left to right, (first row) Elsie Misskelly, Glendora McCarty, Beatrice Hughes, Catherine Stevens, Electa Unsinger, Elizabeth Green, Mary Eckbold, Hilda Roselle, Mary Taylor, Mary Fry, and Pauline Campbell; (second row) Norma Wallace, Leo McArthur, Elizabeth Smith, Charles Jones, Louise Berghaus, Helen Harris, Lashley Nelson, Ella Rowand, Geraldine Warner, Maurice Winner, Minnie Stevens, George Walker, and Rose Clevenger.

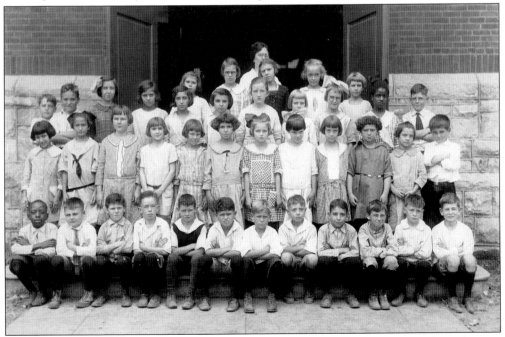

This fourth-grade class is pictured on the front step of the Academy Street School. Students in kindergarten through 12th grades were housed in this building. Many students purchased bus passes and traveled to Clayton to receive their education. Since the railroad station was only a few blocks away from the school, this worked out well for many families.

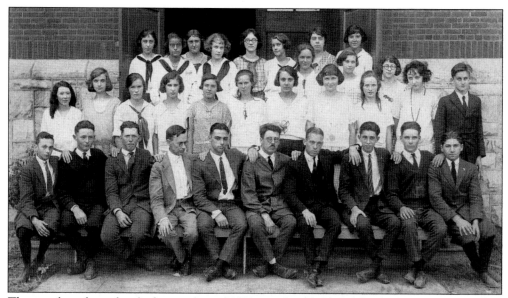

The members from this freshman class of 1922 are, from left to right, (first row) unidentified, Porter Ellis, Miller Van Note, Melvin Goodwin, Mr. Miller, Mr. Shriner, Mr. Brinkley, Charles Hauck, Charles Warwick, and Carl Isman; (second row) Marie Rowson, Isabella Kear, Evelyn Porch, Rose Etri, Alfretta Brown, Mildred Porch, Grace Brown, Miriam Warner, May Kerr, Eleanor ?, and Roger Burn; (third row) Gilda Capozzi, Eleanor Wright, Beatrice Norrie, Florence Thomas, and Edith Stagger, who composed the high school's alma mater; (fourth row) Sarah Ewan, Emma Eckbold, Eloise Hill, Dorothy Bowers, Emma Moore, and Gertrude Hubbard.

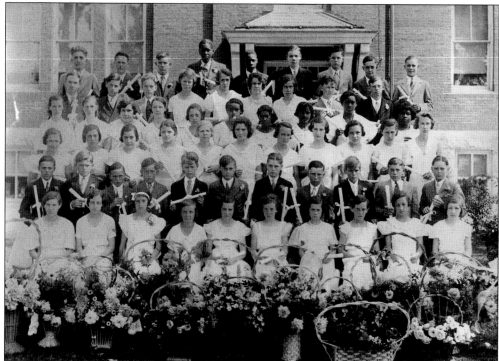

Pictured here is the graduating class of 1933 when they were in eighth grade.

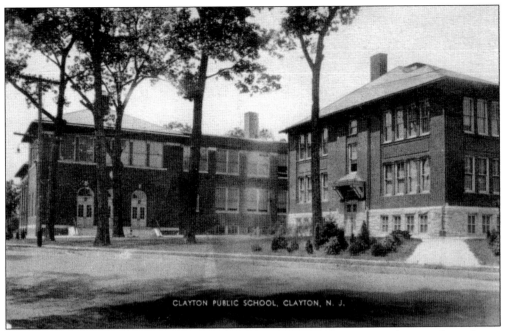

CLAYTON PUBLIC SCHOOL, CLAYTON, N. J.

On this postcard, the addition that was built behind the original school can be seen. It was larger than the initial structure. The addition, which housed a wing for high school students and an auditorium, was built in 1923 to accommodate Clayton's growing population of students.

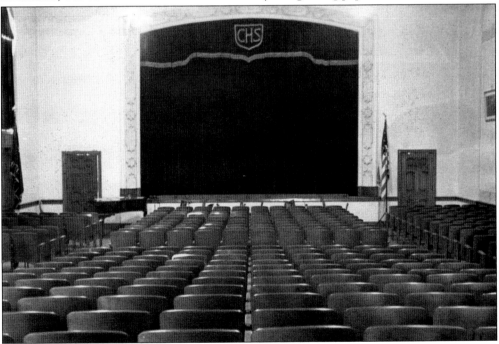

The auditorium was part of the high school section of the school, but it served both the high school and grade school for assemblies, school plays, graduations, concerts, movies, and other large gatherings. The orchestra pit was in the front center. The curtain with the CHS logo and a number of chairs from this auditorium are on display in the Clayton Historical Museum.

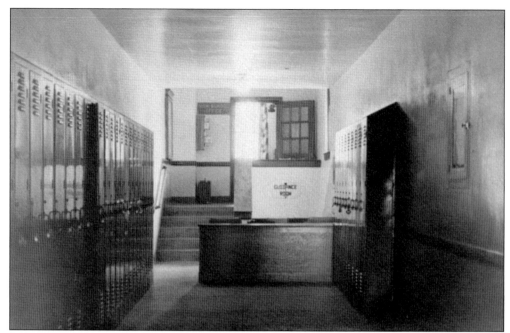

Pictured is the infamous hallway that led to the high school principal's office. The secretaries for the school would sit in the front behind the half wall. Behind them was a doorway leading under the stage, located next door in the auditorium. At a time when it was permitted, the male teachers would head down to this room for smoke breaks.

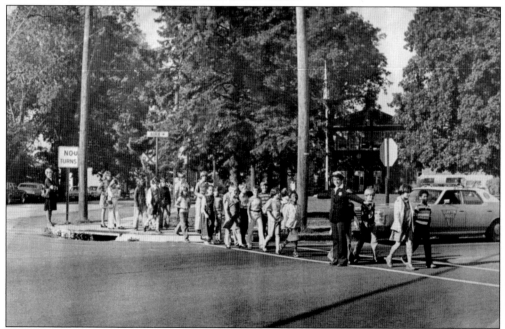

Because it was within walking distance to many students' homes, Clayton schools provided crossing guards at all major intersections. When an electric line along the railroad tracks was installed, students would have to be extra careful as they crossed the tracks, located right behind the school.

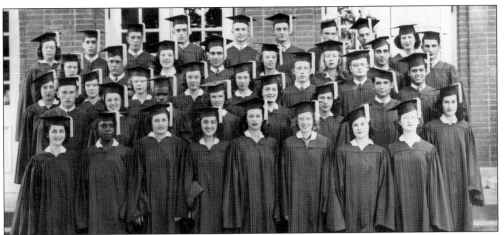

Members of this graduating class of 1947 are, from left to right, (first row) Lucy D'Alessando, Mildred Aaron, Eleanor Tirelli, Jayne Nichols, Helen Weinstein, Charlotte Winner, Edith Jungkurth, and Ruth Fry; (second row) Allan Costill, Delores Wojciechowski, John Jackson, Patty Boarts, Irene Hockman, Helen Char, Frank Pedulla, and Mildred Capozzii; (third row) Martha Spatafore, Peggy Scholtz, Theresa Durand, Ruth Denelsback, Alma Myers, Bob Ernst, Glenn Kindle, and Daniel Sandler; (fourth row) Grace Cheeseman, Angelo Falciani, Mary Smith, Pete Scapalotto, Lillian Turner, Patty Hammond, and Joe Rambone; (fifth row) Bernice Kniveton, Frank Andrews, Edward Hazard, Frank Papiano, Frank Ogle, unidentified, Harold Funnell, Charles Larue, and Vera Buzza.

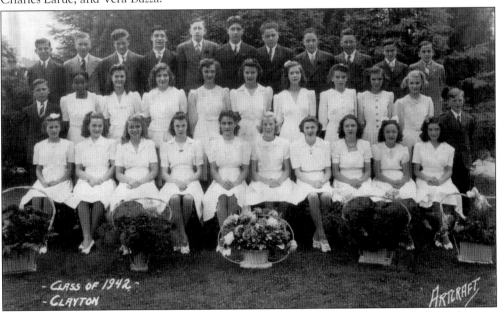

Members of this 1942 eighth-grade class are, from left to right, (first row) Phyllis Atkinson, Winifred Gill, Jane Stewart, June Morgan, Irene Petree, Peggy Oudshoorn, Elenor Cramer, Margery Boarts, Barbara Reese, and Rose Weinstein; (second row) Bill Fisher, Wilhemina Brown, Beatrice Field, Helen Tidmar, Jere Lechette, Alberta Baptiste, Aubrey Warner, Clara Moore, Alice Shipley, Phyllis Adams, and Howard Gant; (third row) John Terilla, Allen Costill, Otis Smith, Geo Hernandez, Donald Gardiner, Jim Bompensa, Ralph Razzi, Albert Cassaday, Walter Tweed, Charles Haegle, and Gene Bessay.

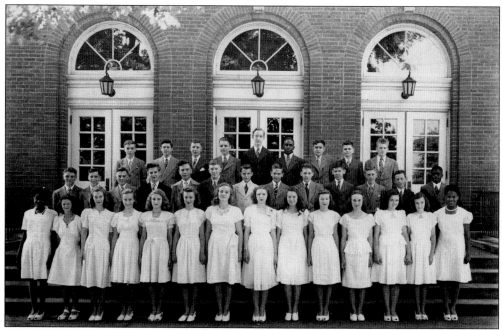

Students in this photograph of the 1946 class are, from left to right, (first row) Maggie Dixon, Barbara Jane Nelson, Lawrence Ermlin, Grace Linsey, Jean Scott, Caroline Silvers, Pat Tucker, Mildred Way, Marie Collins, Phyllis W., Jeanne R., Thelma L., Ester C., and Lucille B.; (second row) Edgar H., Eugene E., Keith G., Donald B., Bobby G., Charles D., Emile B., Charles W., Leslie M., Jack Q., Joseph M., Jesse B., and Thomas J.; (third row) Thomas Q., Donald D., Billy S., Charles G., Ray Roth, Billy B., Russell H., Gilbert N., and Jina G.

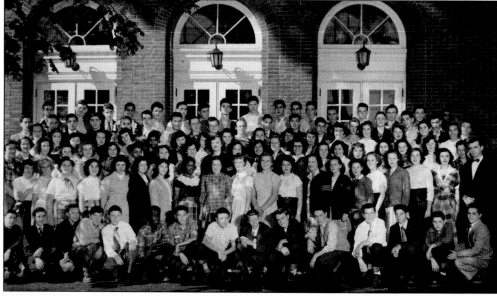

The proud class of 1954 is pictured when they were mere freshman in 1951. At the time, this was the largest freshman class to ever walk the halls of Clayton High School. The class consisted of 53 boys and 55 girls. The student body would become smaller in future classes because many students began to attend Delsea Regional High School.

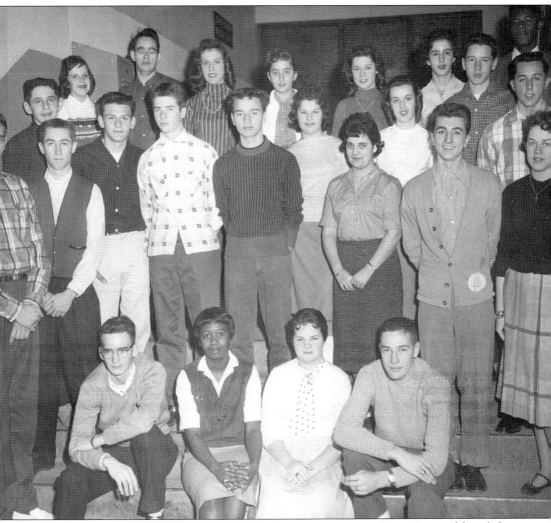

The homeroom presidents of 1959 were responsible for monitoring attendance. Pictured from left to right are (first row) seniors H. O'Brian, J. Walker, G. Burns, and F. Kier; (second row) juniors D. Ferrell, W. Streitz, C. Fabrizio, R. Moffa, and J. Senior; (third row) sophomores A. Muller, J. Danyliw, G. Hammes, N. Azeglio, M. Recchio, L. Kier, and E. Dougherty; (fourth row) freshman P. Wiseburn, J. Mounier, L. Grochowski, S. Buchanan, P. Cekaivice, B. Schmitt, and L. Jones.

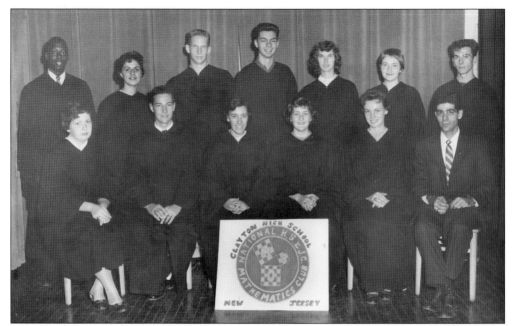

The members of the 1959 National Mathematics Society are, from left to right, (first row) Judith Dougherty, Fredrick Kier, Shirley Samit, Linda Devlin, Jo Ann Clevenstine, and Mr. Buscemi; (second row) Charles Murray, Doris Terilla, Robert Filler, Charles McNally, Caroline Libb, Myrna Schechter, and John Tumminia.

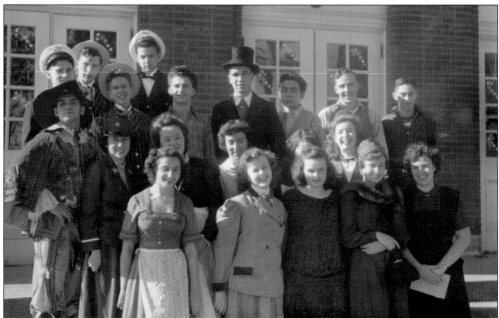

In 1950, the Clayton High School Drama Club performed *Our Hearts Were Young and Gay*. During this performance, club director Francis A. Uzzo had to be hospitalized and the responsibility fell on student director Jeanne Gallucci and the rest of the cast to pull the show together, which they did. Uzzo entered the service during the Korean War and died in 1951. The National Honor Society bears his name in honor of his service.

Freshman class officers of 1951 borrowed a car for this yearbook picture. There were only five officers, though six students are pictured. Officers are Thomas Ianni, Jay Sharp, Louis Caccese, Ruth Winters, and Dorothy Milligan.

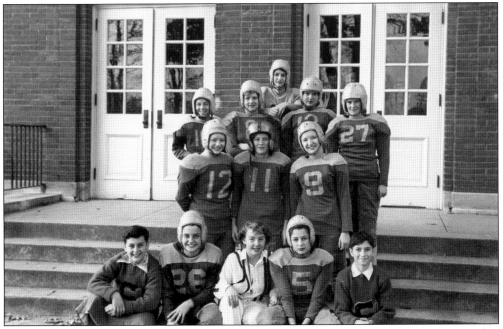

In this 1950s photograph, it looks like a powder puff team is posing, but a more likely story is that some of the senior girls dressed up in football gear to take a silly picture for the yearbook.

Charles "Pop" Kramer was Clayton High School's physical education teacher who joined the staff in September 1925. He is pictured here giving a reward to a student. At that time, most schools' physical education teachers also coached all of the sports teams. Kramer coached a number of first-place teams. During his first year, the baseball team won the first of several championships.

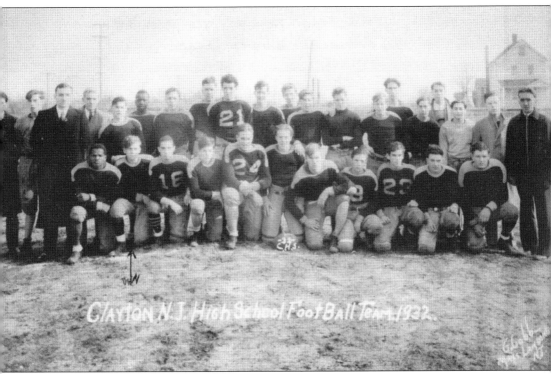

The 1932 Clayton High School football team members who can be identified are June Thomas, Woodrow Currington, Sam Marano, Ralph Newell, Bob Weir, John Steg, Isaac Taylor, Bill Maloney, Bill Fischer, Gene Simkins, John Ferrell, Morris Weinstein, Larry Davidson, Charles Morris, Harry Bell, Jesse Harris, ? Turner, ? Zeidner, and coach Charles "Pop" Kramer.

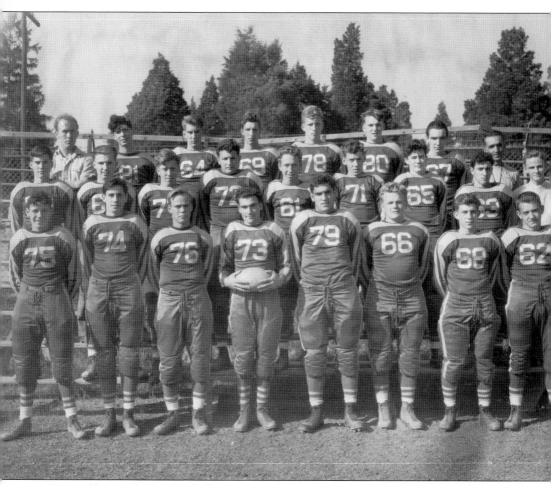

Pictured here is the first football team to win a tri-county championship title under the coaching of Charles "Pop" Kramer. The year was 1939, and it was the first of many titles to be won under the leadership of coach Kramer.

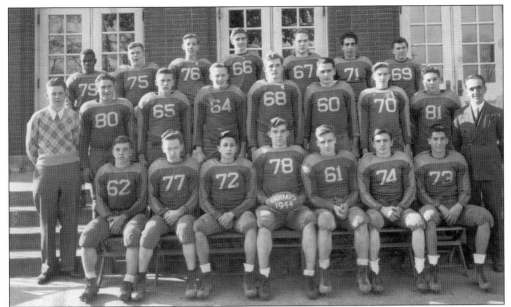

Another championship team coached by Kramer was the 1944 tri-county football champs. They are, from left to right, (first row) Clyde Moyer, George Rowson, Robert Defeo, Boardman Taylor, Paul Loth, Bill Mazowski, Paul Rambone, and coach Charles "Pop" Kramer; (second row) Ralph Fox, Paul Gallucci, Allen Costill, Harry Humphreville, Charles Humphreville, Louis Mongeluzzo, Chester Bell, and Joe Scavelli; (third row) John Jackson, Ed Moore, John Shaerer, Frank Ogle, Don Rogers, Joe Rambone, and Harold Brewin.

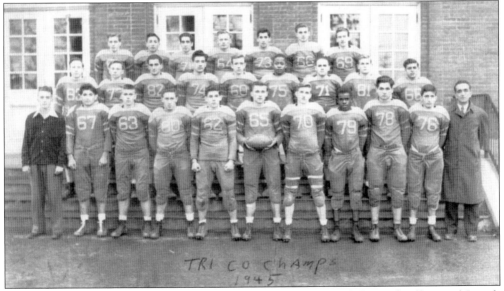

Members of the 1945 first-place tri-county football squad are, from left to right, (first row) Joseph Wright, unidentified, Robert Coblentz, Paul Galluci, Thomas Tucker, Alan Costill, Chester Bell, ? Jackson, Michael Mongeluzzo, Anthony "Hick" Ruggiano, and Charles "Pop" Kramer; (second row) Robert Ernst, George Schmidt, unidentified, Joseph Tonelli, Nicholas Granato, Arthur Shipley, ? Harris, Edward Moore, and Daniel Sandlier; (third row) William Lenard, Robert Defeo, unidentified, ? Rambone, Charles Humpreyville, Frank Ogle, and unidentified.

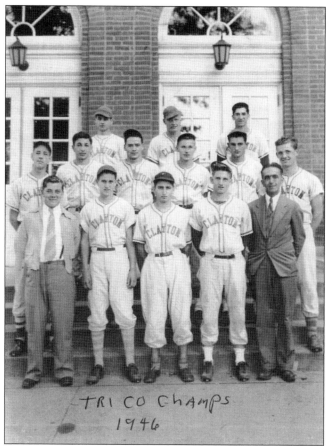

TRI CO CHAMPS
1946

Another team Kramer led to a championship title was the 1946 tri-county baseball champs. Members of this team are, from left to right, (first row) Clyde Moyer, Charles Haegle, Anthony Ruggiano, Chester Bell, and Charles "Pop" Kramer; (second row) Paul Schearer, Robert Defeo, Louis Mongelluzzo, Alan Costil, Joseph Tonelli, and Charles Humphreville; (third row) unidentified, Harry Humphreville, and Paul "Slim" Rambone.

Pictured here are members of Clayton's first cross-country team. They are, from left to right, (first row) manager F. Dougherty, G. Lacey, L. Lundy, R. Digh, S. Becker, J. MacNeil, J. Raspa, and manager M. Hahn; (second row) coach John Scavelli, E. Quigley, R. Shivers, J. Dougherty, R. Hunstinger, S. Pundeok, H. MacNeil, and H. Senseman.

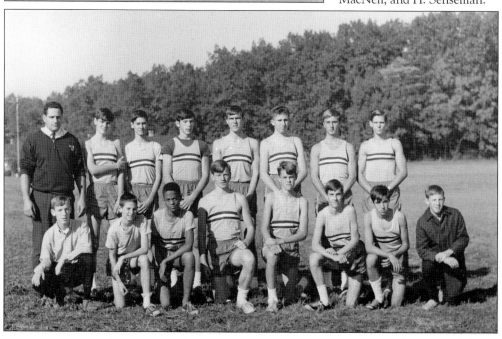

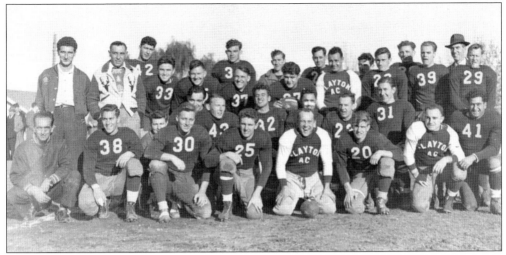

In this photograph is one of Clayton's numerous athletic club teams. During World War II, young men entered the war without ever having the chance to be a part of a high school athletic team. So local towns formed athletic clubs that offered friendly competition for these young men. The players were a mix of high school students and men that were a few years out of high school.

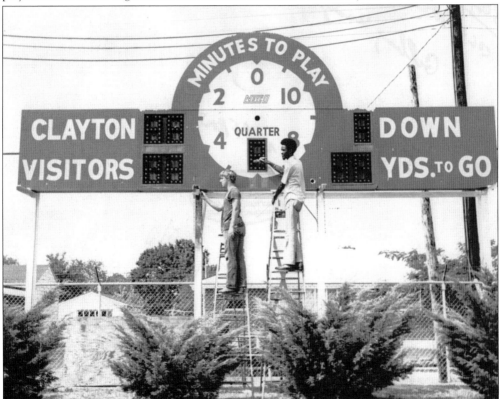

The scoreboard pictured here was donated by the Clayton Jaycees. The Jaycees were originally known only as the letters "J" and "C," which stood for "junior chamber of commerce." It was a civic organization that sponsored a variety of functions like Easter egg hunts and a "Rode-e-o," which was an obstacle course for young drivers that promoted safety.

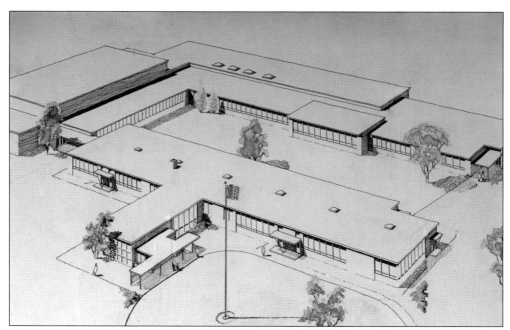

In 1955, the Clinton Street School was constructed to house elementary school grades. Years later, the school switched with the Academy Street School—the latter housed elementary grades while additions were made to the Clinton Street School, which eventually was used for middle and high school grades. Half of the class of 1968 never attended the Academy Street School because this flip-flop occurred at the end of their sixth-grade year.

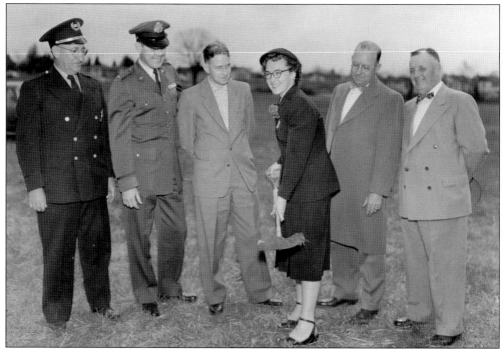

Pictured here is the ground-breaking for Clayton High School's observatory. To the far left is Clayton police chief Howard Vail.

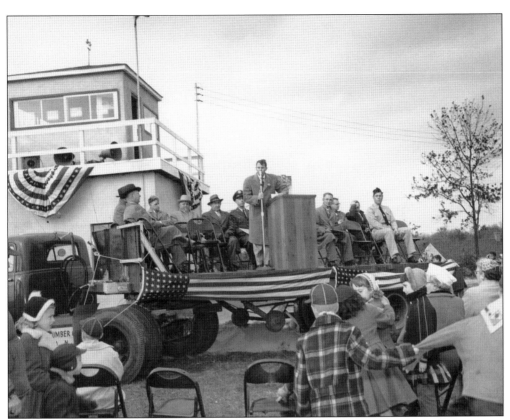

After the Second World War, American citizens felt very confident and safe, though that sensation began to change in the 1950s when China and Russia became enemies and the cold war began. In Clayton, a fear arose that the opposition would fly across the ocean and drop a bomb on Philadelphia, Dover Air Force Base, or even Washington, D.C. The U.S. Air Force developed civilian posts across the nation that would be manned by volunteers to help spot potential air attacks. Clayton joined the program, and on November 5, 1955, the Mary Walker Post of the Ground Observer Corps was established. It is pictured here surrounded with local supporters.

The Mary Walker Post of the Ground Observer Corps was located on a hill at the east end of Howard Street. It was only active for a few years before radar technology became more advanced and rendered the corps unnecessary. The tower was given to the Clayton School District, which used it as the high school science department's observatory. It was torn down years later when the high school expanded to build an auxiliary gym.

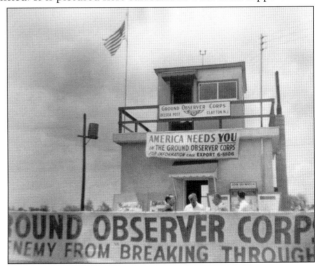

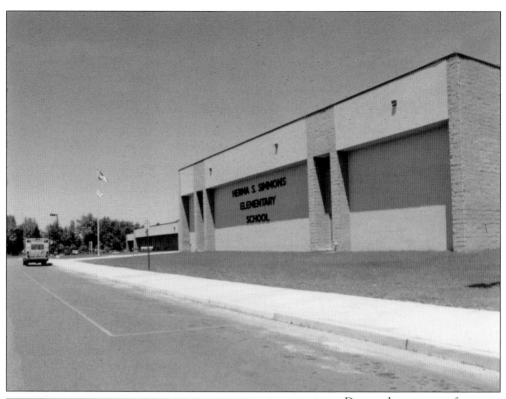

Due to the amount of money needed to refurbish the Academy Street School, the decision was made to build a new elementary school instead. The site chosen was mid-block of Chestnut Street and Erie Avenue. The school opened in 1989.

The new elementary school was named in honor of Herma S. Simmons, a Clayton High School alumnus who returned to become a teacher and coach at the school. She eventually became principal of Academy Street Elementary School. Simmons served in World War II where her German ancestry helped the American war effort.

Three

AROUND TOWN

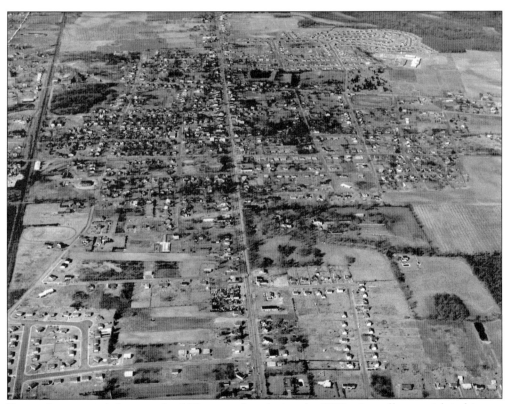

Pictured is an aerial photograph of Clayton taken during the 1960s. A small town rich in history, Clayton developed over the years, and as the needs of the town changed, new buildings were erected. Some of the town's older buildings that were not replaced with modern structures were lost to neglect. This chapter looks at the historic buildings around town.

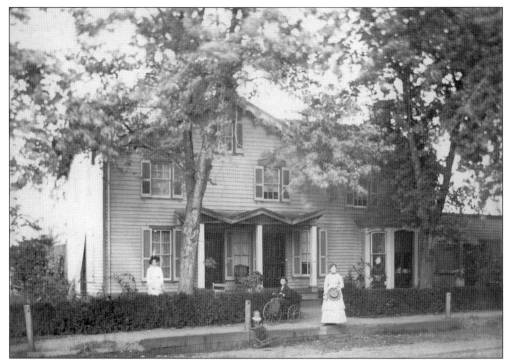

This home was once owned by D. W. Moore, brother and partner of John Mayhew Moore, is one of the oldest residences in Clayton. It has had many additions over the years; the original log cabin was located where the bay windows are. This home still stands on Academy Street behind the Heritage Dairy Store.

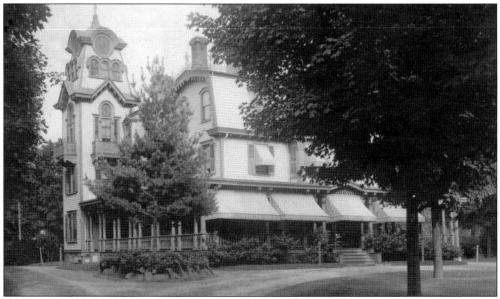

John Moore commissioned the Moore residence, pictured here, and Richard T. Beckett was hired by him as the carpenter. Moore had it built on the site of his old residence, then moved the house to Delsea Drive in 1887. It took workers more than a month to move, and they said the grandfather clock never stopped ticking during the bumpy transition.

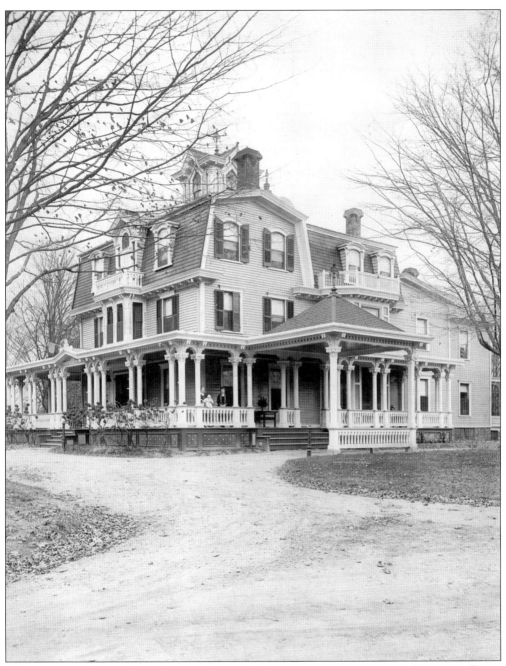

The Moore residence changed ownership multiple times; at one time it was known as Grove Lawn Estates. The property was beautifully shaded by many different species of trees that were planted by John Moore. Private residents lived there up until 1969. In 1971, it was torn down and apartments were built in its place.

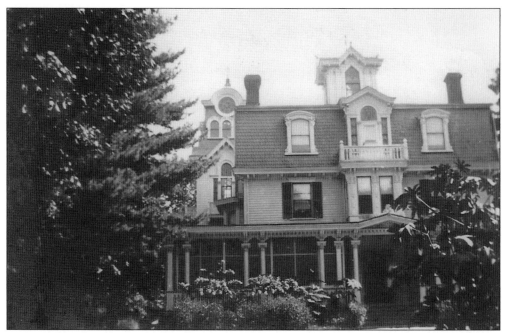

The house itself was three stories high, had a deep basement, fruit and wine storage areas, six large rooms on the first floor, another six rooms and two bathrooms on the second floor, and seven rooms, including a billiard room, on the third floor. In addition was the tower room, which contained three balconies. From the highest balcony in the tower, the entire estate was visible below.

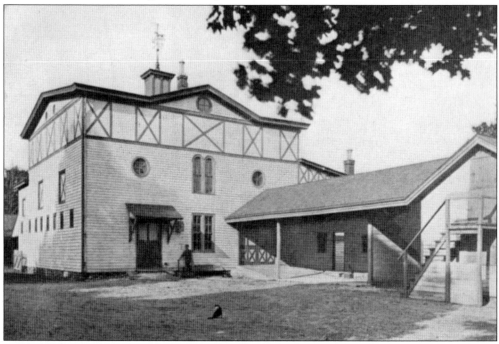

Pictured here is the large stable located behind the Moore residence. Inside the stable were five horse stalls, four cow stalls, a chauffeur's room, carriage room, spacious loft, and cemented cellar. Outside this building are auto and carriage stands and an icehouse.

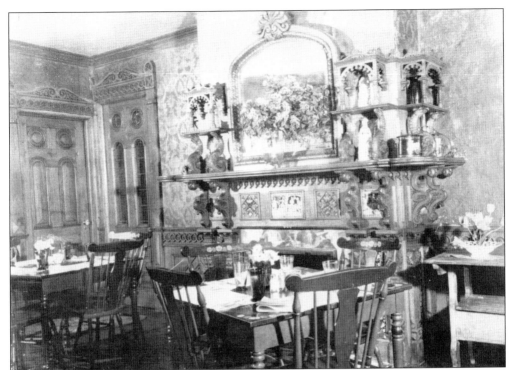

In the summer of 1933, a small tearoom opened in what had been the billiard room. The hand-carved mantle seen in this picture is very unusual. Through word of mouth, business began to grow, meaning the tearoom had to expand. An old drawing room was used to seat 60 guests, a private dining room accommodated 30 diners, and during the summer a screened porch could seat 30 more.

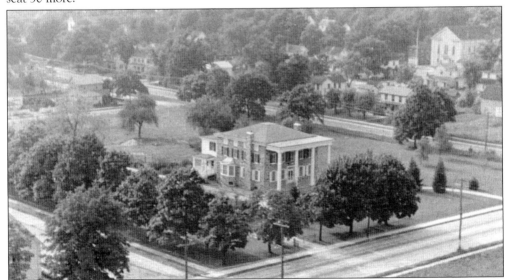

The Moore mansion is pictured here in 1937. The original structure was altered when it was purchased by Pierre DuBois, who added the pillars and stone facing. The mansion was torn down in the spring of 1971, and is the site of the present-day Acme. In the background of this picture, taken from Clayton's water tower, is the old town hall.

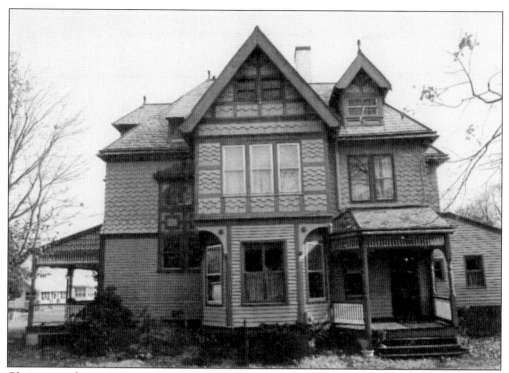

Clayton was home to more than one glass factory. F. M. Pierce and Company was located in the northwestern part of town. The business started out as Fisler and Morgan Company and, at one time, was also known as Clayton Bottle Works. Owner Franklin Pierce built a lovely home, pictured here, which still stands at the southeast corner of Broad and Centre Streets.

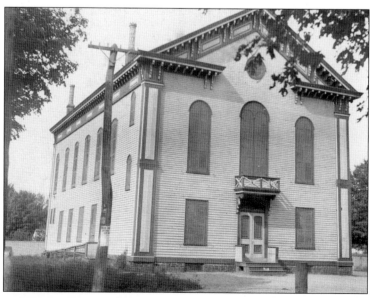

Clayton Town Hall, pictured here in 1906, was referred to as the "opera house." It is noted as having state-of-the-art acoustics, which benefited the various plays and concerts that were performed there. The town hall also housed the library and, for a period of time, a dress factory. A single-cell jail was located in the rear of the building so local drunks could sleep off their stupor.

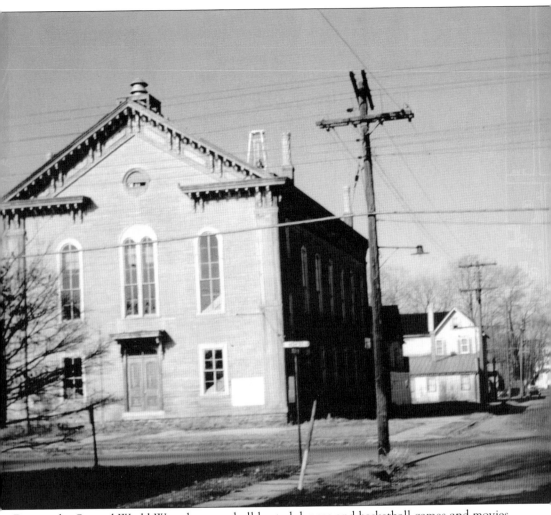

During the Second World War, the town hall hosted dances and basketball games and movies were shown on the second floor. For a short time, roller-skating was also held inside town hall, though that activity ended because it damaged the floor. Clayton Town Hall was torn down in the 1950s to make way for a new firehouse.

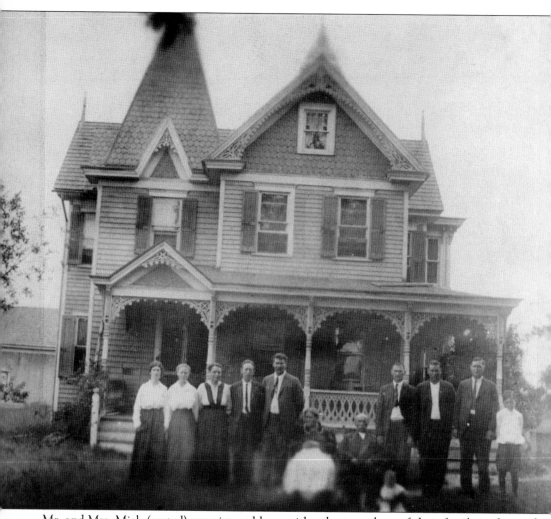

Mr. and Mrs. Mick (seated) are pictured here with other members of their family in front of their home on the northwest corner of Broad and Maple Streets. This photograph, which was taken around 1920, shows the house located across the street from what is presently Barclay's Funeral Home.

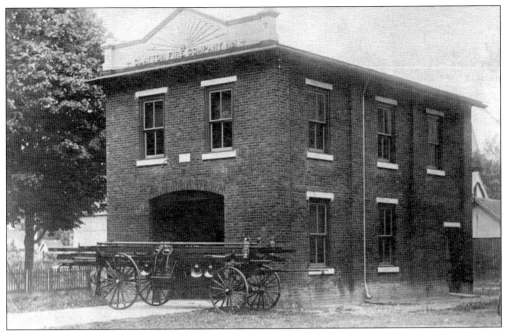

On December 10, 1895, fourteen Clayton citizens met at town hall to organize a fire company. From that meeting, the Hope Volunteer Fire Company was formed. Eight years later, by borough ordinance, an official fire company was formed on December 4, 1903. The first firehouse, pictured here, was erected in 1910 on the west side of town hall.

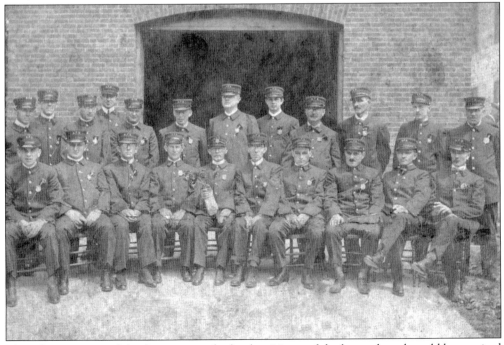

Men who were part of the fire company had to be citizens of the borough and would be required to surrender their keys, coats, and boots if they lived outside that vicinity. Typically the men who volunteered spent time on the second floor waiting for a fire run.

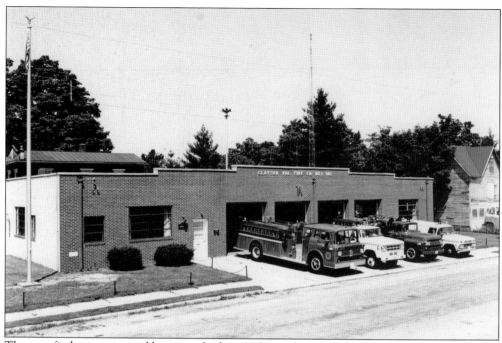

The new firehouse, pictured here, was built in 1959 on the northwest corner of High Street and Pearl Street, on the site of the old town hall. In the background, the original firehouse can be seen; it was used at this point in time as the town's first ambulance hall. The new firehouse was needed so it could house larger trucks.

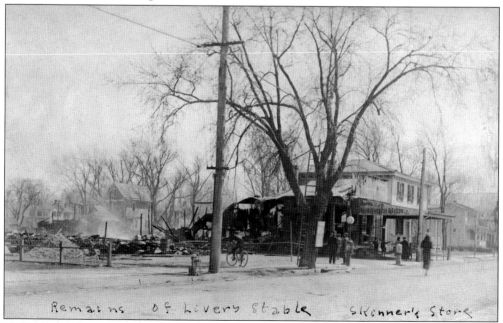

Remains of Livery Stable Skinner's Store

In this photograph the remains of Skinner's Store on Delsea Drive can be seen after it fell victim to one of Clayton's biggest fires. The fire, which occurred in the early 1900s, began inside the store and its embers caused the fire to spread over a two-block area. Surprisingly, due to the wind, it did not burn the house next door.

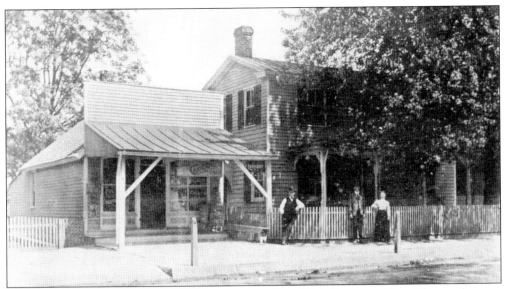

Shreve Store was located on Delsea Drive between East High Street and East Clayton Avenue. The store's owner, Billy Shreve, pictured leaning against the fence above and in front of his store below, sold a variety of items from tobacco to magazines. The house located next to the store was his residence. In the 1930s, the store housed a bakery. It continued to change hands and at one time was operated by Jack Peterson. The store's name changed to the Clayton News Agency when it was owned and operated by Thelbert "Puggy" Snyder. Later the name would change again to E and L New Agency. A photography studio is located there today.

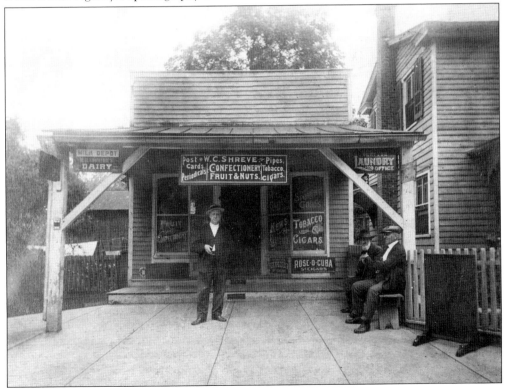

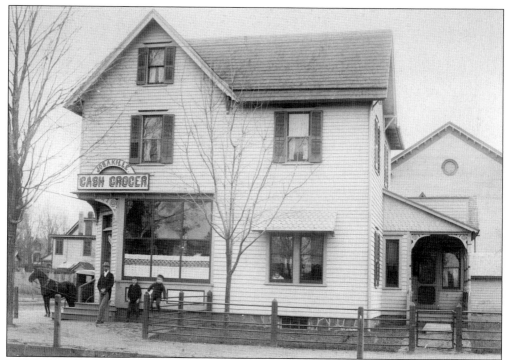

Joseph A. Kille's grocery store stood on the southwest corner of Maple and Pearl Streets. In addition to groceries, he sold wallpaper and paint and was regarded as a well-accomplished painter and wallpaper decorator. The building would become H and H Upholstery; now it is a private residence. In the background, the old town hall can be seen.

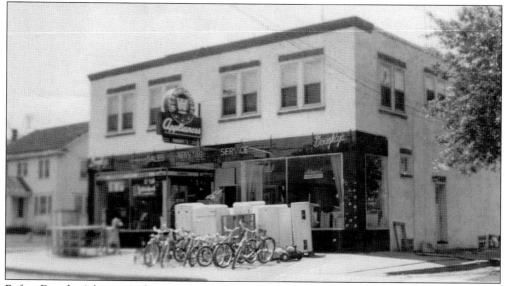

Before Doughty's became a furniture store, it was an appliance store. Opened in 1946 by Harry and Clara Doughty, the retail center sold electronics and hardware. Doughty later sold the business to one of his salesmen, Ray DeMoine, who moved Doughty's across the street. Under this new ownership, the named changed to Ray's Appliance Store and the business operated successfully for a decade. Today the building houses Movie Man and Tan.

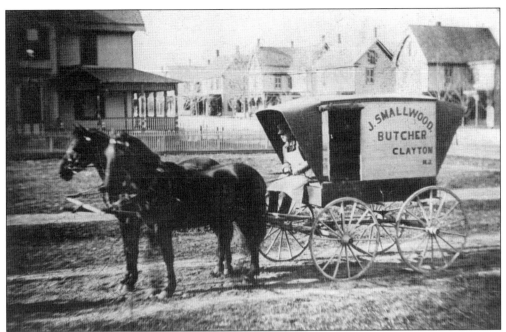

As the town of Clayton grew, there arose an obvious desire and demand to meet the needs of the area's increasing population. Up-and-coming businesses also wanted to prosper, so they began offering new home delivery services. Before motorized vehicles became the popular means of transportation, businesses used horse-drawn delivery wagons. Two such businesses in Clayton that used this method to deliver to their customers were J. Smallwood's butcher shop, pictured above, and Klinger's Bakery, pictured below. These horse-drawn delivery wagons were a common sight on the streets of Clayton.

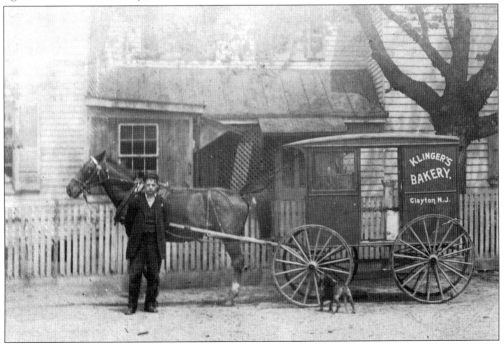

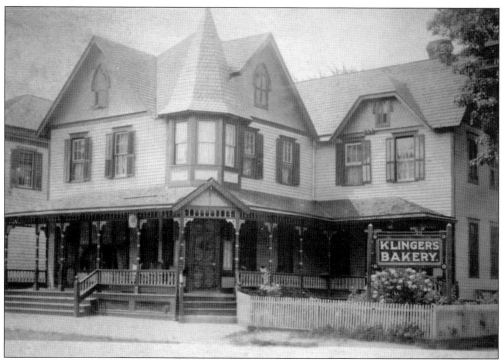

Klinger's Bakery was located on the corner of Delsea Drive and West Center Street. A number of businesses have occupied this residence besides this bakery. At one time it was a clothing store owned by a family named Campbell. When Haegele's Bakery operated there, the baking was done in the cement block building located behind the house.

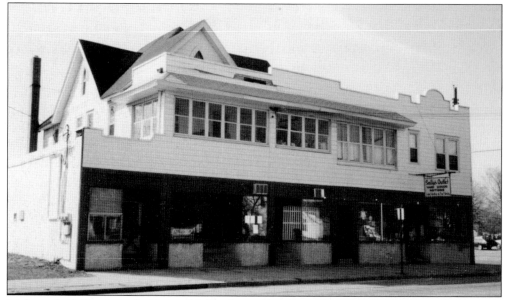

In the early 1940s, a storefront was added to the residence in order to house a number of businesses. The second floor was converted into apartments. The new storefronts were home to the American Store Company, Ruth's Nook (a coffee shop), Clayton Title and Trust, Bernstein's Drug Store and Variety Store, Dot and Sam's Deli, Sally's Outlet, and Carbon Copy.

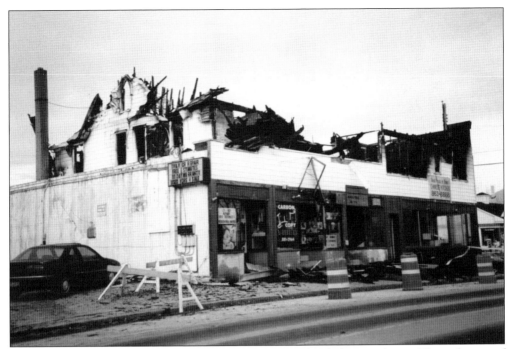

In the early 1990s, a fire destroyed parts of the house behind the storefronts. The only part of the building that presently contains any remnants of the original residence is the foundation in the back of the structure.

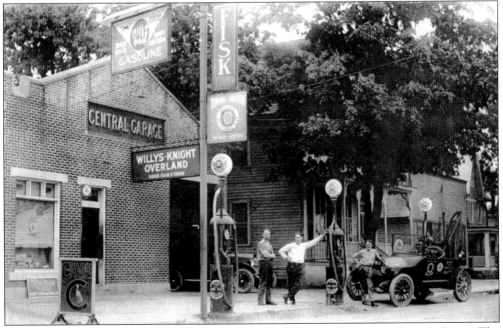

Central Garage was located on Delsea Drive between West High Street and Maple Street. The store to the left of the garage sold Cranes Ice Cream to the youth of Clayton. The garage was located next to an A and P Food store run by Les Turner. Later the garage would become Turner and Turner Garage, owned by George and Russell Turner.

George "A. J." Alexander's store was located on Delsea Drive between East High Street and East Center Street. At one time, the building was home to Clayton's ambulance corps. It was located next to the town's theater, the Spectorium, where silent movies were shown. Today the municipal building is located along this same stretch of Delsea Drive.

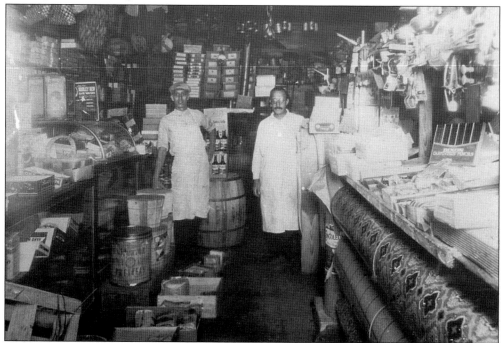

Many families would employ their children in an attempt to keep the business in the family, and George Alexander was no exception. In this 1924 picture of the interior of the store is George's son Jesse Alexander (left), who worked in the store with his brother, George Alexander Jr. (right).

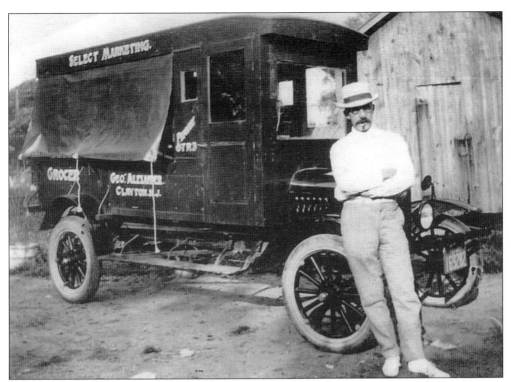

As time went on and automobiles became more available, businesses ended the practice of using horse-drawn delivery wagons and opted for motorized trucks. Pictured is George A. J. Alexander with his 1918 1-ton Ford truck, which he used to make deliveries for his grocery business. The body and lettering for the truck were done by Daniel Frazer, a blacksmith from Hardingville, New Jersey. In the below picture, Alfred, who also worked for George, is posing with the same truck.

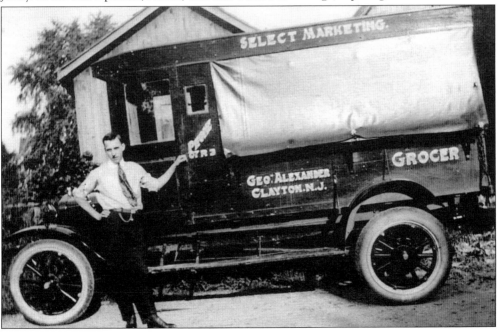

The residence in this photograph is the Campbell family farmhouse. The Campbells owned a pasture directly behind their house, which is located on Delsea Drive between Maple Street and West Center Street. When Norman Morris, who owned a gas station next to the house, decided to expand his business the Campbell home was torn down. The gas station was eventually torn down and a Dunkin' Donuts now operates on the site.

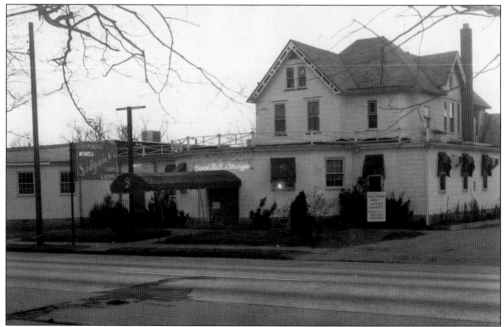

Sedgwick's was a local restaurant on the northwest corner of Delsea Drive and Morton Street. Before it was known as Sedgwick's it operated as the Delsea Drive-In and also Oscar's Delsea Drive-In. After the death of Oscar, his wife, Frida, took over the restaurant and changed the name to Frida's Delsea Drive-In. Frida was known for having a pet skunk.

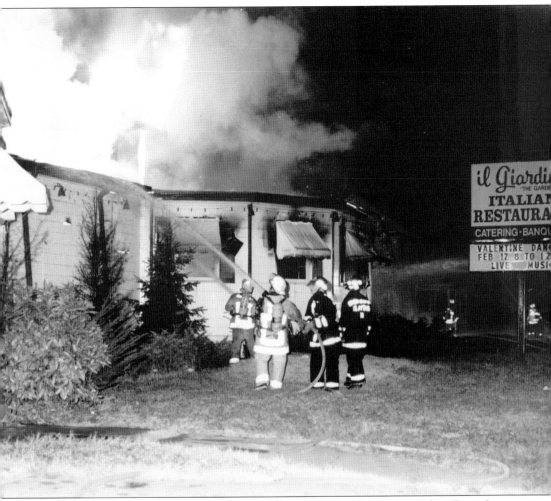

The restaurant had a number of different names over the years. After Frida's Delsea Drive-In, it became known as Sedgwick's, then Edward's Carriage House, then Luke's. After that, the restaurant returned to being called Sedgwick's before finally taking the name Il Giardino. With that name, the restaurant burned down in the early 1990s and was never rebuilt. Presently there is a Rite Aid on this lot.

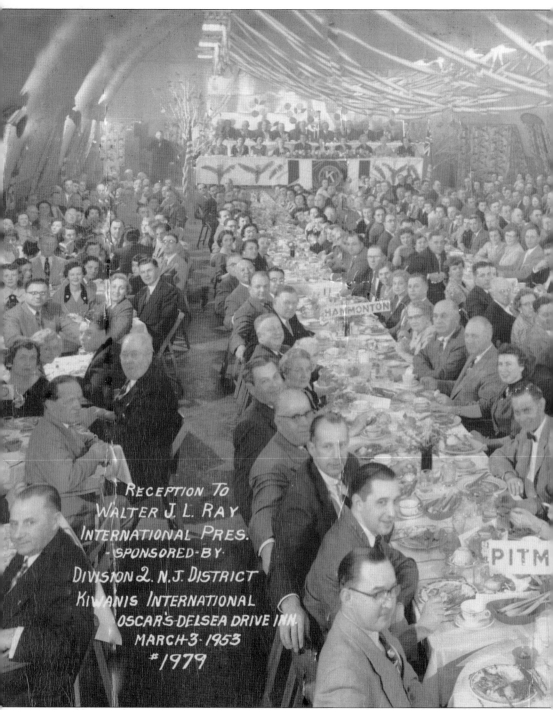

RECEPTION TO
WALTER J. L. RAY
INTERNATIONAL PRES.
-SPONSORED-BY-
DIVISION 2. N.J. DISTRICT
KIWANIS INTERNATIONAL
OSCAR'S DELSEA DRIVE INN
MARCH-3-1953
#1979

In addition to being a restaurant, Sedgwick's hosted and catered events such as wedding receptions, local organizations' banquets, and school functions such as proms and award dinners. Functions such as these were held behind the actual restaurant inside the Quonset hut, which was built in

the late 1940s. One such event can be seen in this photograph from March 3, 1953. Local Kiwanis club members and many other supporters celebrated a reception for Walter J. L. Ray.

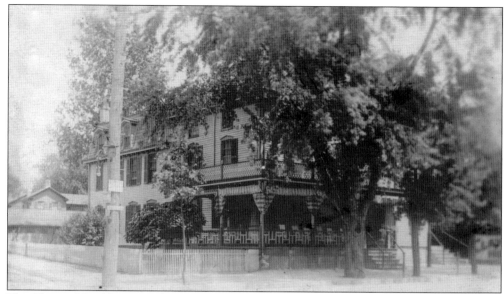

The Clayton Hotel began as the Davis Hotel and was located on the southeast corner of Delsea Drive and Academy Street. It was built by Charles A. Davis between 1855 and 1865. After his death, the hotel came under the ownership of John M. Moore. Townspeople banned together, removed all the alcohol from the hotel, and had a celebration ushering in a more sober society. Moore oversaw the meeting, and Clayton Hotel became a place where many temperance groups from around the area would meet.

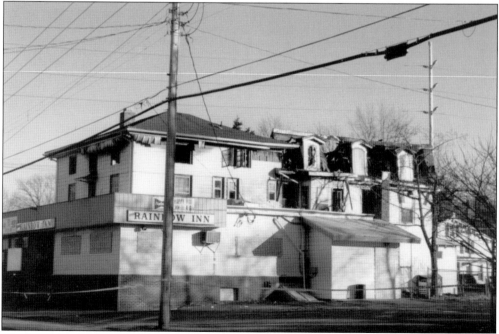

The hotel has had multiple owners and names. It has also been known as Hibbard's Hotel, Schwenk's Hotel, Masso Hotel, and eventually the Rainbow Inn. In 1995, a fire destroyed most of the structure. During reconstruction, the corner nearest the intersection remained standing and became part of the newly constructed Rainbow Inn.

In this photograph is one of the old two-room schoolhouses used before the Academy Street School was constructed. After students began attending the Academy Street School in 1908, this building was left vacant until the 1930s when it was used by the Pet Mill Dog Food Company, operated by George Temple.

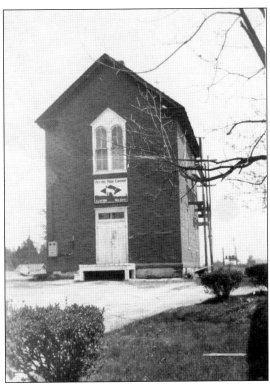

The Stanger Store was located on the northwest corner of Broad and Academy Streets, within sight of the Academy Street School. It sold a few groceries and basic supplies but was known as the candy store to Clayton's youth, who would wait in long lines outside the store. The Stanger Store moved to Smithville in the 1960s, where it still stands among other historical structures around south Jersey. It is pictured here in 1968.

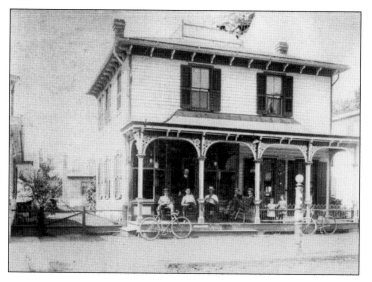

Roselle's Barber Shop, which opened in the late 1800s, was located on Delsea Drive between Maple Street and West Center Street. It was a popular gathering point for the men of Clayton who would come just to hear the latest news. Many of Roselle's customers had their own shaving mug with their name on it. The barber pole in front was not electric; it had to be wound-up in order for it to turn.

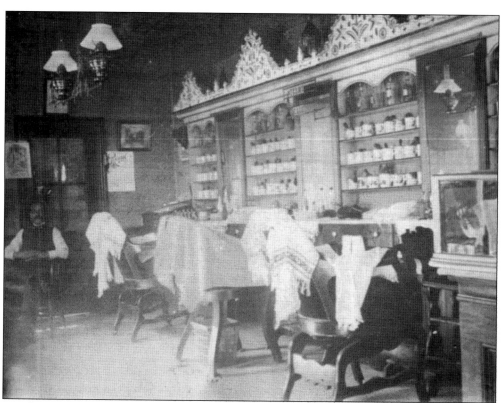

Roselle's Barber Shop was presided over by Wilbur Roselle, also known as "Barber Roselle." He usually employed an assistant since it was a multiple-chair shop. In addition to giving shaves and haircuts, he also sold cigars, cigarettes, and pipe tobacco. One of the benches from his barbershop is on display in Clayton's municipal building in the court/council chambers.

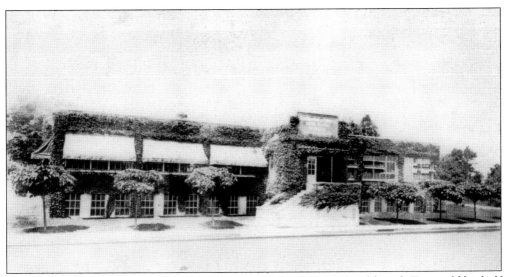

Churchill Hungerford and Arthur Terry incorporated in May 1909. Although Terry sold his half of the business in 1921, his name was never removed, and Hungerford began searching for the perfect location for his water conditioning business.

One building Churchill Hungerford inspected as a possible location for his business was the defunct William Brown Shoes Company, a half-constructed building in Clayton that Hungerford described as a dump. One day when Hungerford was out of town, his son was approached by the same businessman that Hungerford previously turned down in regards to purchasing the "dump" building. The businessman convinced Hungerford's son that his father already made a deal, so his son followed through and bought the run-down structure. When Hungerford returned and learned of the sale he had the building refurbished. He took great pride in having the grounds restored as well. The company is still headquartered there today.

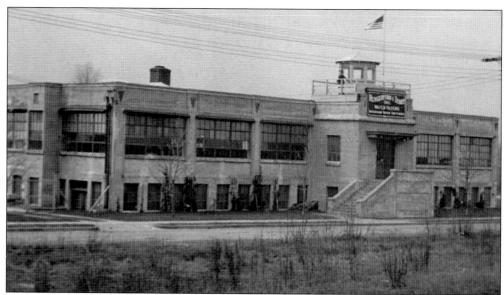

During the days of World War II, a lookout bunker was added to the top of the Hungerford building. Local citizens, trained by the military, were stationed there to watch for enemy aircraft. If they saw what they believed was a threat approaching, the citizens were to contact the U.S. Army Air Corps base in Millville, and fighter planes would be sent to intercept the aircraft.

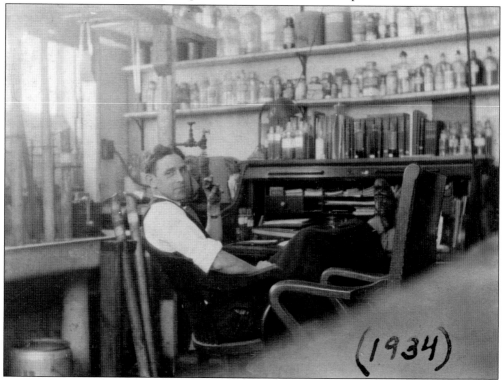

Clarence Edwards was a chemist in 1934. Here he is pictured in the first research laboratory at Hungerford and Terry, Inc., which is still known today for its specially designed water treatment units. Edwards served as mayor of Clayton in the late 1950s and early 1960s.

These workers from Hungerford and Terry, Inc., are, from left to right, (first row) Bob Whitehead, Al Langberg, two unidentified, Chick Oga, Hayden Hungerford, John Forester, Albert Nauta, and Frank Myers; (second row) Harris Gerschwint, Bailey Ross, Walt Gilbronson, unidentified, Serino, Alling, Dave Hungerford, Carl Schulz, Churchill Hungerford, unidentified, John Reutter, and Raymond Meyers. The woman in the window is Peggy Wagner.

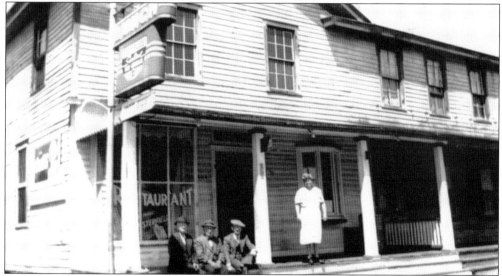

Marty and Barb's began as a factory outlet store for the Moore brothers' glassworks and later Pierce Glassworks. The Moore brothers paid their employees in scripts or shinnies—company money—which could only be spent in company stores. Before the store was purchased by Martin and Barbara Kolsun in 1966, it was known as Currington's and also Jim and Mae's grocery store.

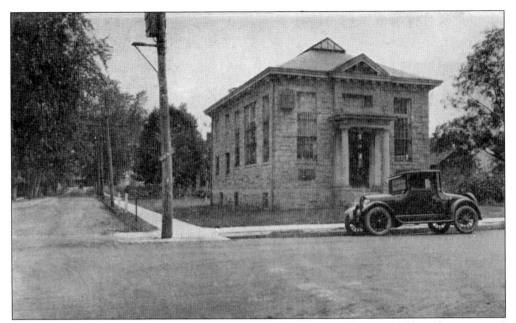

Clayton National Bank opened for business on Friday, February 2, 1914. Although its original location is unknown, it moved to the southwest corner of Delsea Drive and High Street in December 1915, as seen in this postcard.

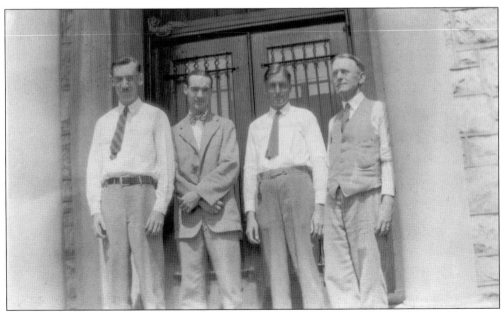

This picture was taken on the steps of Clayton National Bank in July 1927. In this picture are, from left to right, Wilbur Fry, assistant cashier; Tom Fay, teller; Roy Busby, bookkeeper; and Walt Dubois, cashier. Given the size of the town, this was the complete staff of the bank at that time.

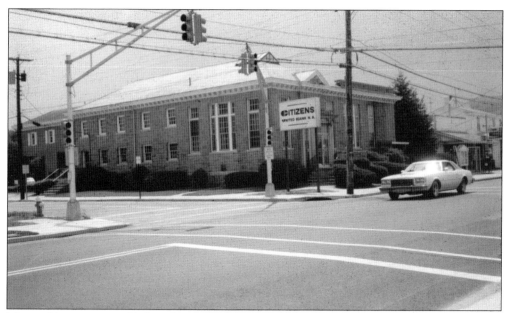

Many additions were added to the original bank building, including a second floor and a drive through. Clayton National Bank has changed hands and names many times over the years. It was also called the New Jersey National Bank, the Peoples Bank, Citizens Banks (as pictured here in 1984), Corestates National Bank, First Union, Sovereign Bank and, in 2001, the Bank—the simple name it still holds today.

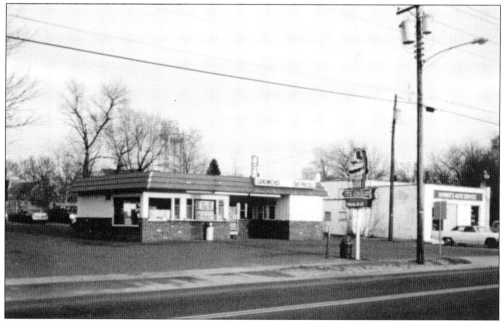

The Twin Kiss ice cream shop was a popular hangout for the teens of Clayton and surrounding towns. The original building was a trailer that was transported into town and placed at its location. The name Twin Kiss was well known at the time because the franchise held the patent on "twist" cones. Teenagers that wanted a chocolate and vanilla twist ice cream cone had no choice but to find a Twin Kiss. The business was also regarded for the root beer that was made on-site.

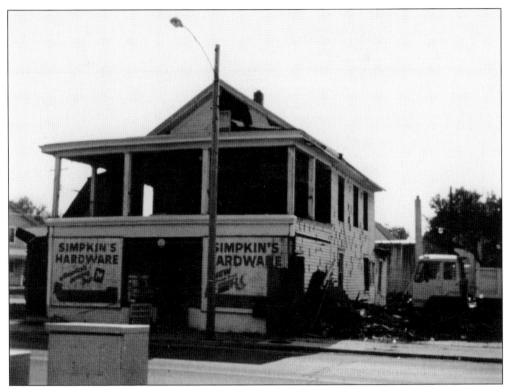

Simpkins Hardware opened after World War II, operating in a small building located on High Street between Delsea Drive and South Pearl Street. Eventually Simpkin purchased the whole northwest corner of Delsea Drive and High Street. This house, before it was purchased, was a number of restaurants. Through the years it has been Moore's Restaurant, Chew's Restaurant, and the Blue Plate. Lastly Jack Wiseburn ran a coffee shop there before it became a hardware store.

A staple in the community, the hardware store sold a variety of building supplies and tools to the citizens of Clayton. It has since closed, and the building remains today as a reminder of the once-successful business.

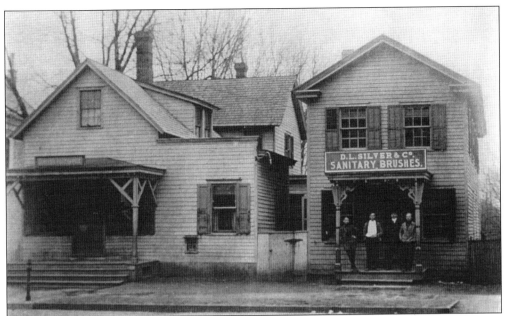

The Sanitary Brush Company started in 1907 on Maple Street by D. Linton Silver. Although not even old enough to vote at the time he opened the business, Silver was very passionate and optimistic about his profession. As business grew, he bought the factory in this picture—located next to the post office, at the time, on Delsea Drive—and took on a partner named Mr. Chamberlin.

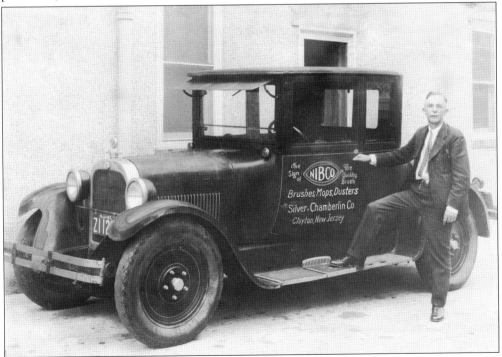

In 1913, Silver and Chamberlin introduced their new trademark, NIBCO (New Idea Brush Company), which can be seen on the side of the vehicle in this picture. This car was used by salesmen to advertise their product.

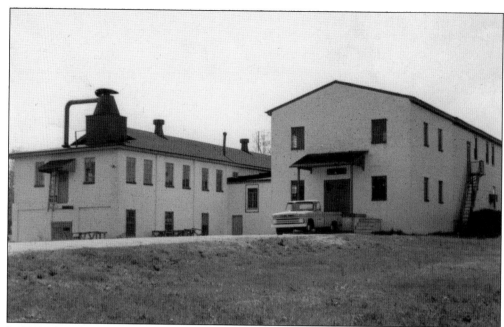

In 1912, a new brush factory was built next to the railroad. It grew to over 5,400 square feet—larger than the previous buildings. Surprisingly by 1918, Silver and Chamberlin's factory was again too small and another had to be built. The newly named Silver Chamberlin Brush Company employed more than 50 workers and 200 salesmen and produced more than 1.5 million brushes a year.

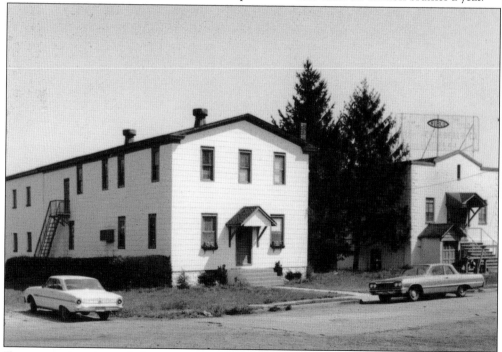

To meet product demand, the company needed faster parcel post delivery. So in 1923 a sub-post office opened up inside the factory, which allowed the Silver Chamberlin Brush Company to keep its guarantee of prompt service for more than 20 years.

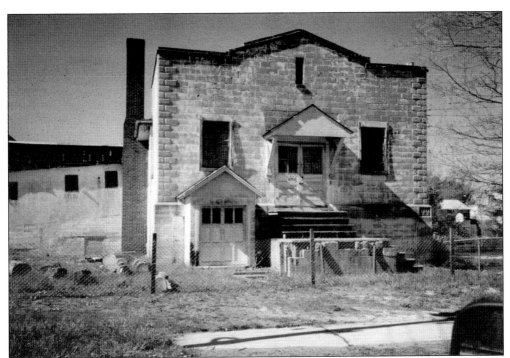

In this photograph, the factory is seen as it looked on April 24, 1999. The cornerstone reads "1919," which would indicate this was the second factory built. As time passed, the company was bought by the Ox Fibre Brush Company of Fredrick, Maryland, and was made a subsidiary. That deal lasted until 1953 when the Pro-Phy-Lac-Tic Brush Company of Florence, Massachusetts, bought the controlling shares of Ox Fibre Brush Company.

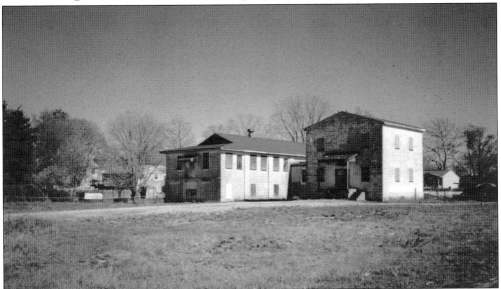

Company buy outs unfortunately led to the closing of the Silver Chamberlin Brush Factory in 1955. Its employees were asked to work in either Maryland or Massachusetts, where the parent companies were located. The empty factory buildings were used as storage facilities for local Clayton businesses, including Glick Antiques and Doughty's Furniture.

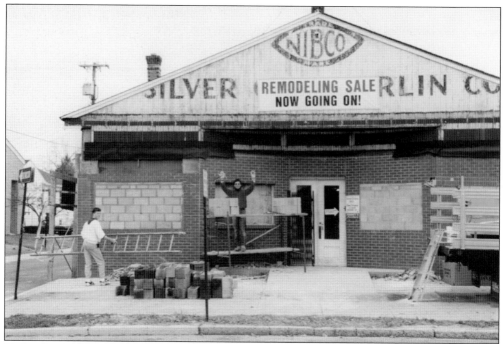

Today this building is Doughty's Furniture, but prior to 1970 this portion was separate from the rest of the furniture store. This storefront was part of the former Silver Chamberlin Company, as seen on the old sign in this photograph. Pictured is Thelbert "Puggy" Snyder with his hands in the air. Prior to being owned by Silver Chamberlin, this store was Skinner's Hardware Store in the 1930s and Pet Mill Dog Food in the 1940s.

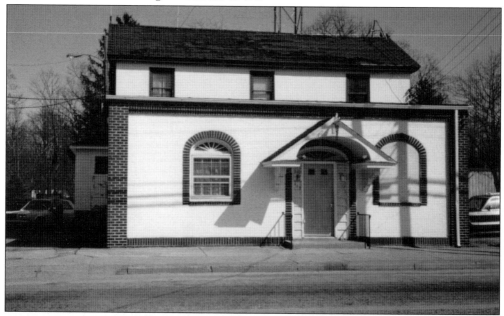

Clayton Title and Trust operated in this building in the 1930s. In time, it would be obtained by the borough and transformed into the Clayton police station. The second floor used to contain apartments that were available for rent.

In the rear of the police station was a communications tower, seen in this photograph. The tower itself has its own history. Before the police department utilized it, the structure was a light tower used at Alcion Racetrack—a NASCAR track in the 1940s and 1960s—in Pitman, New Jersey.

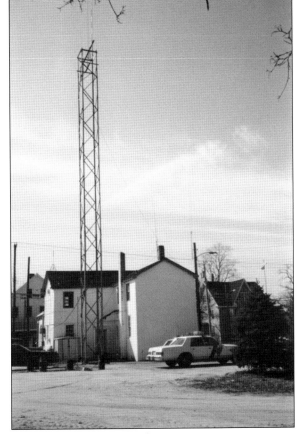

This building has been home to many businesses, including Ben Turner's Variety Store, Jim Streeper Plumbing Shop, Firestone Hardware Store, and lastly it served as Clayton Borough Hall. In the rear of the building was the town's library, which was eventually torn down to make room for a new borough hall.

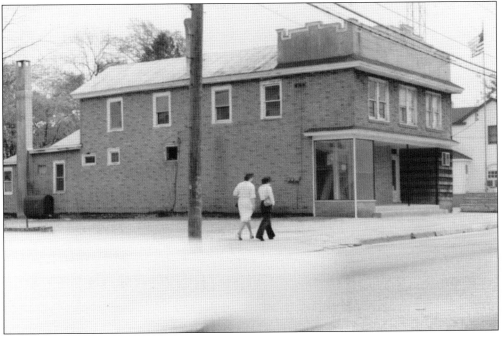

Clayton citizens have a history of serving their country. The town has paid honor to these men and women in a variety of ways. Pictured is a dedication to Clayton war veterans, located next to borough hall.

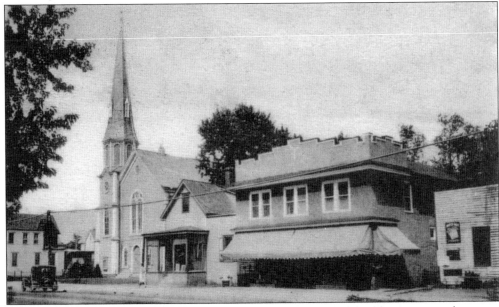

This postcard shows Delsea Drive, heading north. The borough hall building is pictured as it was when it was Ben Turner's Variety Store, where men's and women's clothing were sold on different sides of the store. The shop even had two different entrances for men and women. The small building to the right was at different times a pool hall, shoe repair shop, and antique shop.

This house was located on the northeast corner of Delsea Drive and High Street. The traffic light seen here was installed for an easier exit for the ambulance and fire departments located down the street. It also helped alleviate Friday traffic caused by people cashing their checks at the bank across the street and people driving to the shore.

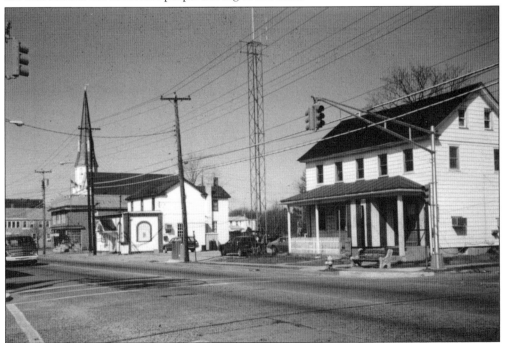

Clayton eventually sought construction of a new and updated borough hall to meet the needs of the town's growing population. Pictured is the street corner that existed before the building was torn down to make way for the new borough hall.

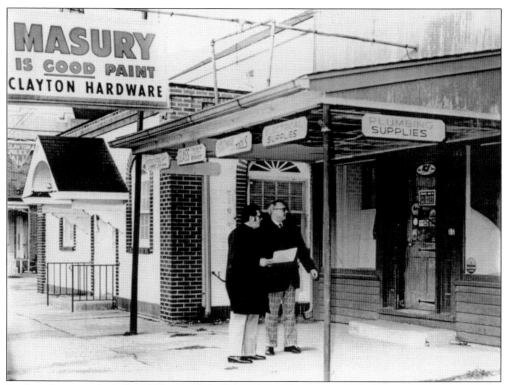

In this photograph is the old borough hall building when it was owned by Joseph Nelson and was a Firestone Hardware Store in the 1940s and 1950s. Nelson was one of the most successful businessmen to occupy the store. Before he owned it in the 1920s and 1930s, Al Krimm had a green grocery store in this building. After that, Al Down sold Norge appliances there.

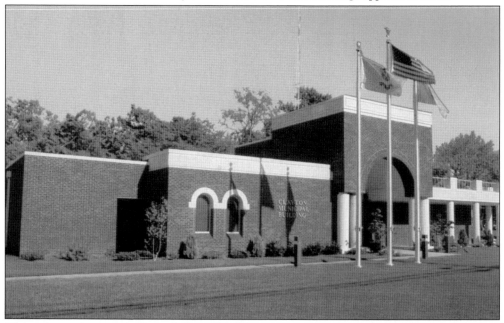

Clayton's new borough hall was dedicated 1984.

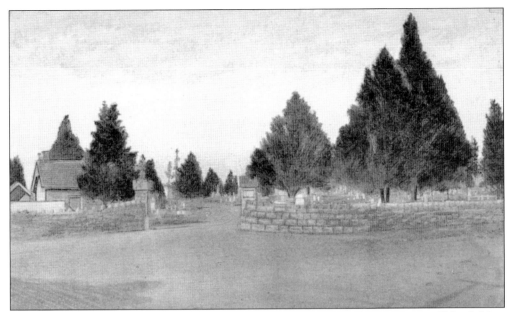

Cedar Green Cemetery is located on the northeast corner of Academy Street and North New Street by Clayton's middle and high school. It covers an area of 15 acres and has more than 10,000 gravestones, many of which are for citizens of Clayton's past and date all the way back to the 1880s. Members of the Fisler family, who founded the town, are buried here.

This house is currently a private residence located on High Street. At one time, Sockwell's Women's Dress Shop, which sold dresses and accessories, operated there. The Sockwell family that ran the store lived in the other half of the house.

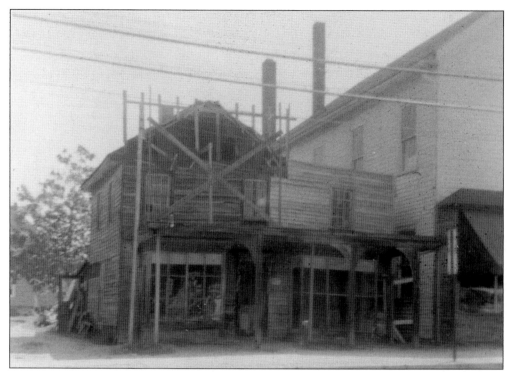

Fred Leigh's store was located on Delsea Drive right off the corner from Center Street, next to what is presently Dancing By Denise. Before Leigh owned it, the store was known as Muchink's Shoe Repair. For some time, there were two gas pumps located in front of the store.

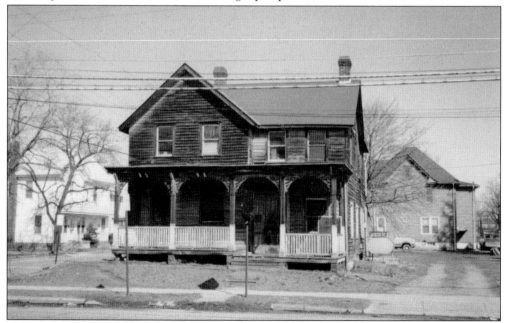

On the corner of Delsea Drive and Center Street was Fred Leigh's residence. Leigh never painted the house because if he did his taxes would be raised due to an improvement to his property. Consequently the house looked this way until it was torn down.

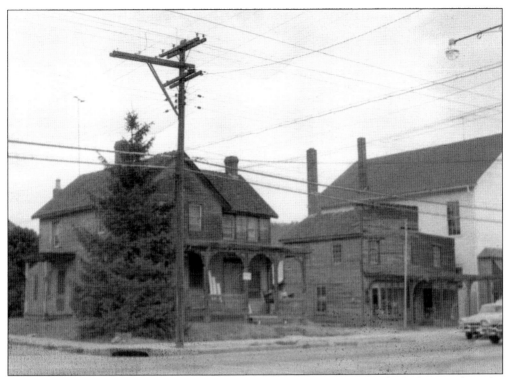

Pictured here is the corner of Delsea Drive and Center Street as it looked when Fred Leigh's residence existed with his store located next to it. Russell Stackenwalt operated the taxi in this photograph.

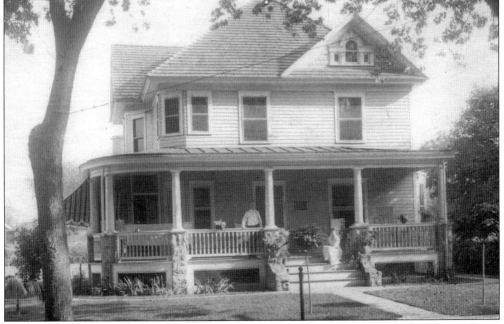

This picture, which was taken in the early 1900s, is of a private residence located on the southwest corner of High Street and Broad Street.

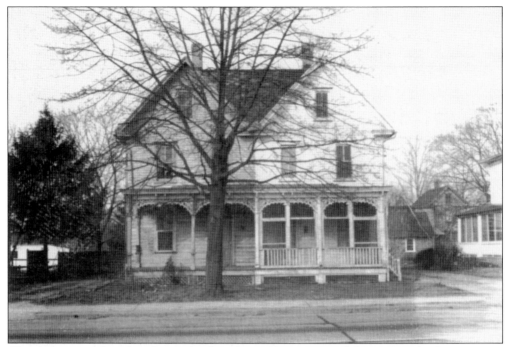

Clayton has a number of residences that have housed businesses and then returned to being private homes. In this photograph is a duplex that was located on Delsea Drive between West Clinton Street and West Howard Street. Behind the house is the building where the *Clayton Press*, the local newspaper, was printed. The house was transformed and a storefront added around the time it became Frank's Barber Shop. The house behind the storefront was eventually torn down; now all that remains is the barbershop, presently called Scott's Barber Shop.

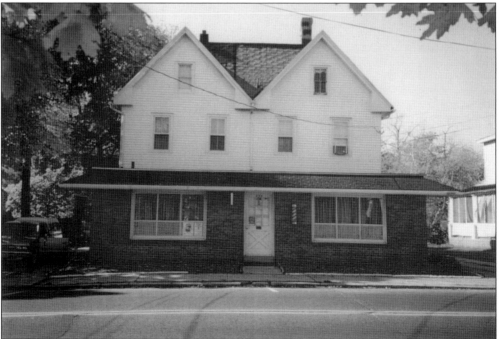

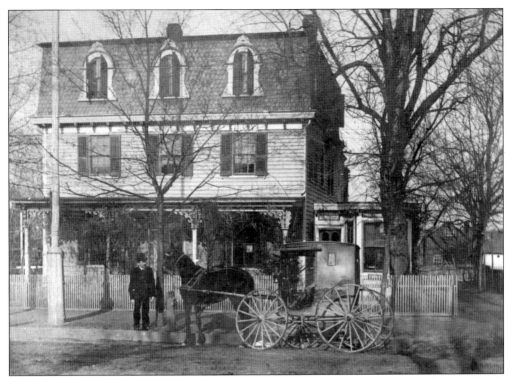

This 1908 photograph is of one of the Wilson family residences, located near Wilson Orchards and Lake.

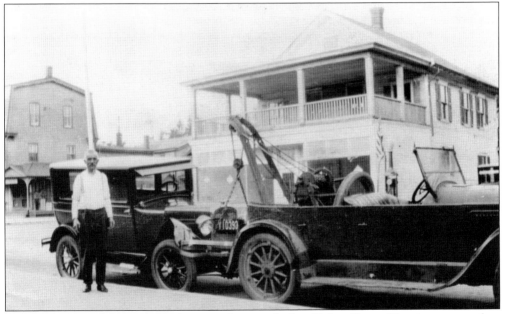

This tow truck and the car behind it were photographed on Delsea Drive. The picture was taken across the street from Central Garage. Behind and to the left of the car is Kindle's Butcher and Grocery Store. The other building in the photograph is the restaurant that was later purchased and used to advertise Simpkins Hardware located around the corner.

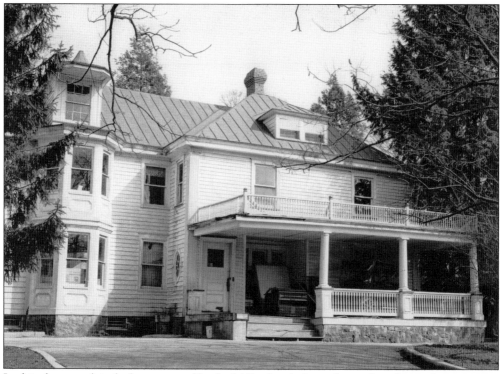

In this photograph is the house owned by the Miller family. It was located on the northwest corner of High Street and Main Street. After the family no longer lived there, rooms were rented and Doughty's Furniture Store used it for storage. In the above picture, a Model T Ford is parked on the porch. In the picture below is the metal fence that surrounded the property, some of which exists today. This house unfortunately burned down and only a few items survived the fire.

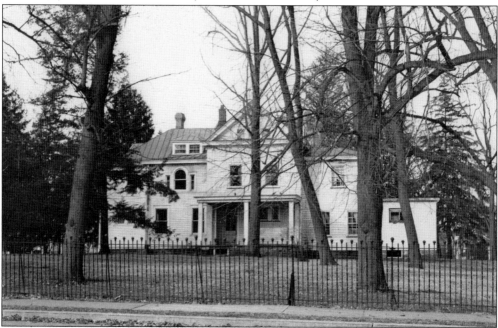

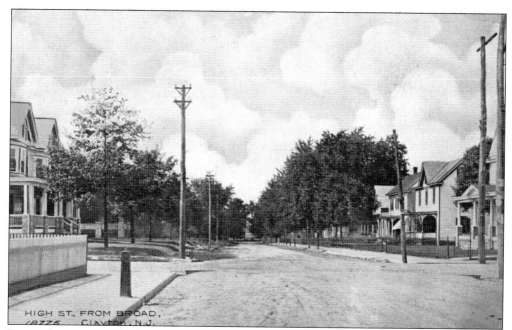

Pictured is a postcard of High Street, which was called Factory Street in 1876 because of its proximity to the glass factory. Many other important buildings were located on this street, such as town hall, the fire station, library, and shoe repair. Located at the end of the road was the railroad station. Notice the hitching post for horses.

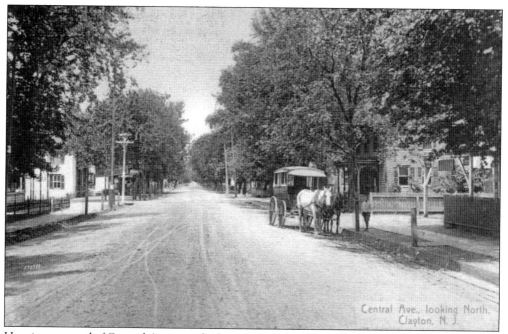

Here is a postcard of Central Avenue, which would later become Delsea Drive. It is pictured looking north, just south of High Street, then known as Factory Street. The street is not paved but the well-kept sidewalks are noticeable, as well as the horse and wagon in front of Shreve's Store.

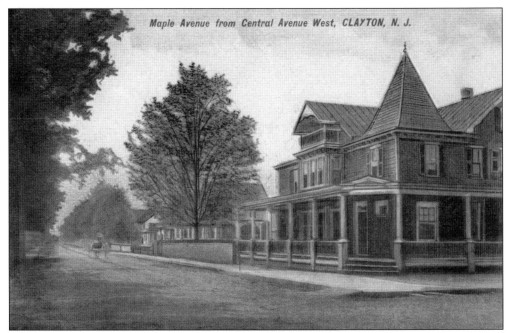

Maple Street was named after the tree that grew along it. Anthony Silver, who married a member of the Chamberlin family and became a partner in the Silver Chamberlin Brush Factory, owned this house. Along this road was also a hotel that is now Barklay's Funeral Home.

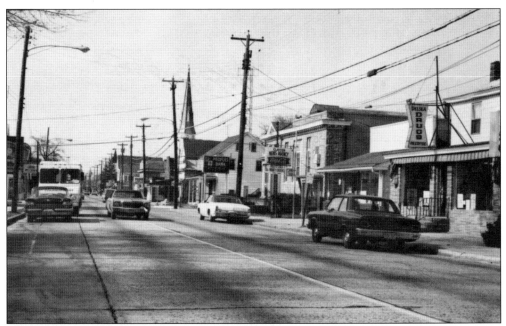

This postcard says Main Street, but it is actually Delsea Drive, looking north. Perhaps it was given this name on the postcard because Delsea Drive was regarded as the "main street" in Clayton. The road was made out of concrete, before pavement became the common material for roadways. Located on the east side is Delsea Drug Store, Clayton's News Agency, People's Bank, and far in the background the Presbyterian church before it burned down.

90

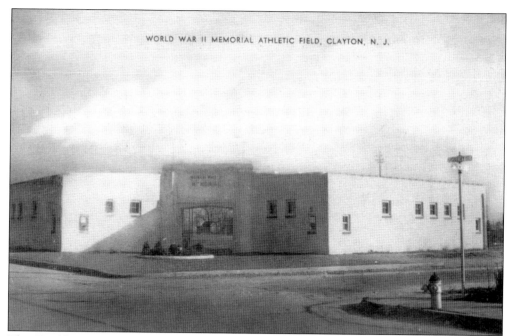

This World War II memorial was built to honor local military men and women; it served as the entrance to the Clayton High School football field. The field was later named the Haupt Field in honor of Nana Haupt, a principal at the high school. This field was the first at Clayton High School to have permanent lighting. People from surrounding towns would come to Clayton to watch a night game.

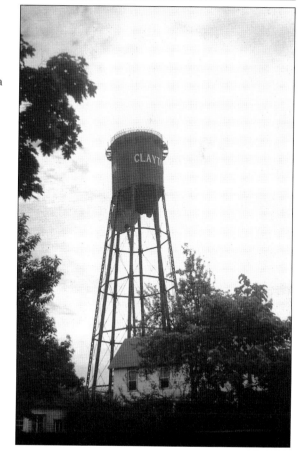

On July 29, 1956, the bottom of Clayton's water tank dropped out. It had recently been repaired after a two-foot-long split developed in the seam on the bottom of the tank. The power of the bursting water tore a 15-foot-long hole in the ground below.

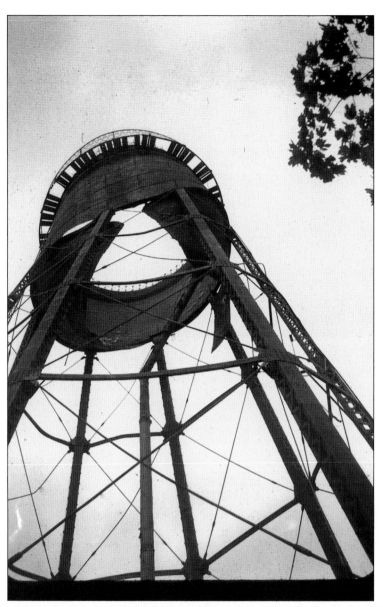

Although it was feared the water tower would topple over, it remained upright. The area around the base of the tower was littered with shreds of trees, fences, and sheds that were demolished by the escaped water. On the day the water tank gave out, nearly 50 chickens drowned in a chicken coop located near the tower.

Edward Luvola owned the original diner constructed at this location. He was a member of Clayton High School's class of 1943. After World War II, he played one year of professional football but broke his leg during the first season. Luvola used the money he made playing football to build the diner, which was later torn down to make room for a new restaurant, the Liberty Diner.

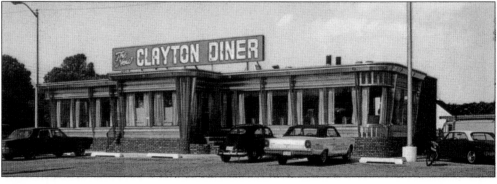

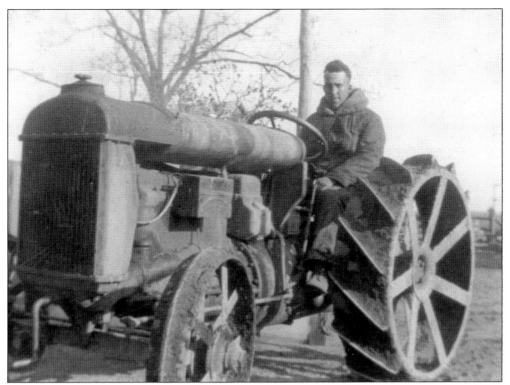

Clayton also had a number of farms within its borders. In this photograph is Everett Groff riding a tractor on his family farm, which was located on both sides of East Academy Street.

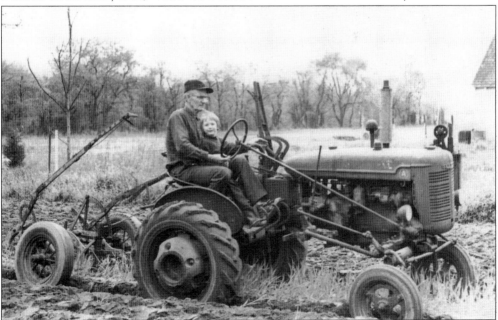

Pictured here is Jesse Robert Gant Sr. (1905–1982). He is riding a tractor with his granddaughter, Marialena Gant. Jesse was a lifelong farmer in Clayton. His 100-acre farm, partially located in the neighboring town of Franklinville, was located on Broad Street and Little Mill Road.

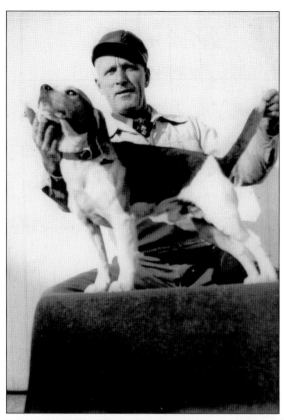

This photograph is of William Gant (1894–1981). He bred beagles and operated a kennel on the Gant farm. He is pictured here in the 1950s with his field champion, Chesco Dandy.

In this 1928 photograph are, from left to right, Synott H. Gant, his daughter Estella G. Currington, and his son William Gant.

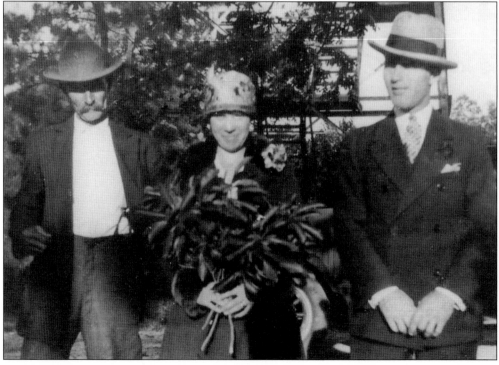

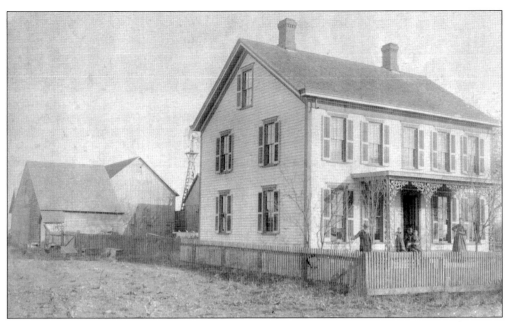

Another farming group in Clayton was the Dubois family. Their farm was established in 1875 and six generations worked on it. The farm was located on the corner of Delsea Drive and Madison Avenue.

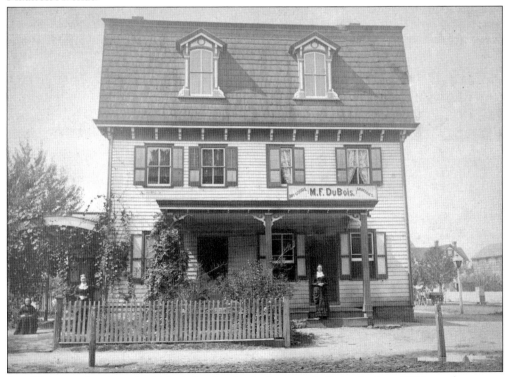

In addition to farming, the Dubois family also had a store built in the late 1800s on the corner of Delsea Drive and West High Street. They sold dry goods and groceries; stock for the store was supplied by crops from their farm.

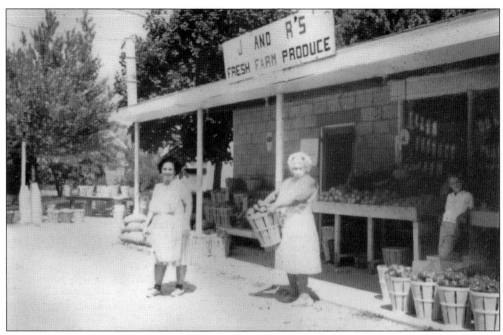

Joseph Puglia was born October 19, 1910, and he later found work on farms during the Depression. He married a young woman named Rose and together they found a home in Clayton. In the early 1950s, they started a 10-yard-by-10-yard farm in their front yard along a stretch of Delsea Drive located on the way to Glassboro. In the early 1960s, they built a grocery store next to their home. They were able to rent 25 acres behind the house and began operating the farm full-time. With their new land, they expanded the grocery store to sell produce. The store was given the name J and R Fresh Farm Produce, as seen in the picture above, with the "J" and "R" standing for Joseph and Rose. The name would later change to Puglia's. The woman on the left in both photographs is Rose Puglia.

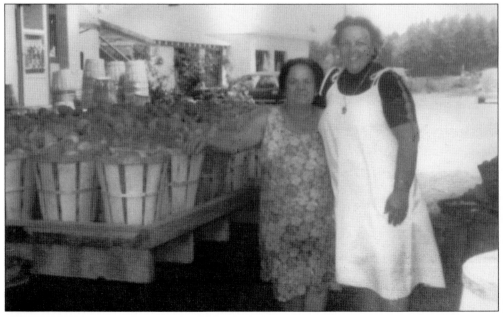

Four

RAILROADS

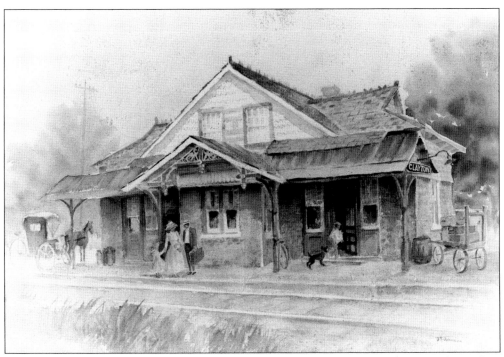

Railroad service came to Clayton sometime in the 1860s. The first train station was located on West Academy Street, the second station was on the southwest side of Clayton Avenue. Clayton's last train station was built at the end of West High Street and is depicted here in a watercolor. All the pictures in this chapter are of the last train station.

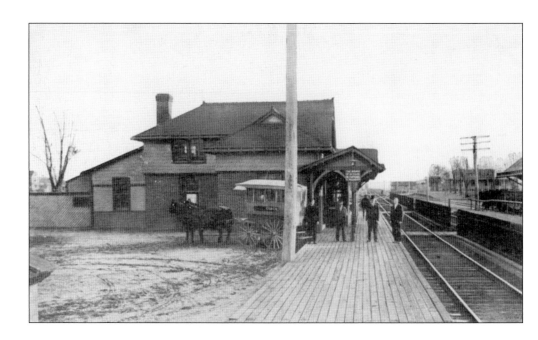

Passengers would purchase their tickets from the ticket master inside the station. Pictured here is the station, looking south. Southbound trains would stop at Franklinville, Malaga, Newfield, Vineland, and Millville. There was one train called the "fish train" that would travel all the way to Cape May. It received its name because fishermen would use this train and head northbound with their catches in wicker baskets.

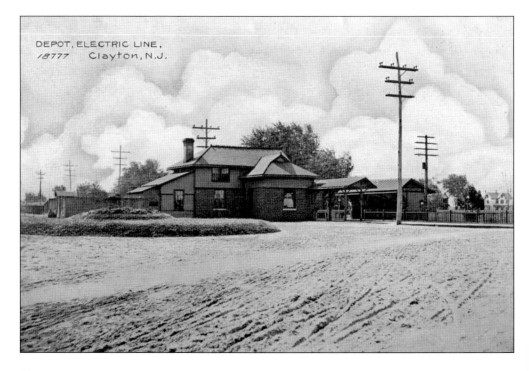

DEPOT, ELECTRIC LINE,
18777 Clayton, N.J.

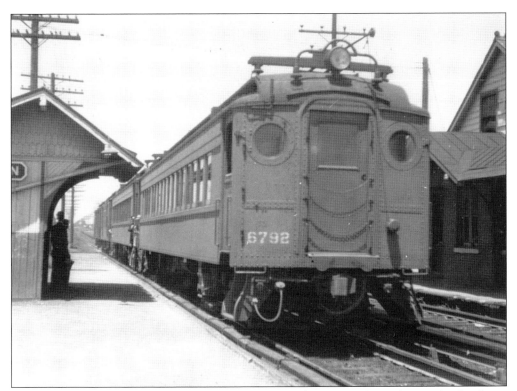

At first, all trains were pulled by steam locomotives. Then in 1906, an electric third rail was installed and self-propelled electric cars became common. With the construction of the bridge to Philadelphia, and many former train passengers now using busses and cars, there were far too few patrons to justify keeping the third rail energized. The last electric railcar left Clayton on June 25, 1949.

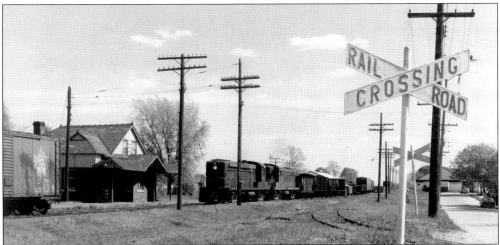

Pictured here is Clayton Station as it looked in the spring of 1964. Notice the rail line running off the side, in the direction of Hungerford and Terry, Inc. This is one example of a spur that branched off the main line. Others spurs were to Alleris Aluminum Products, Pierce Glassworks (located at the end of West Howard Street), and the Moore brothers' glass factory (located along Clayton Avenue).

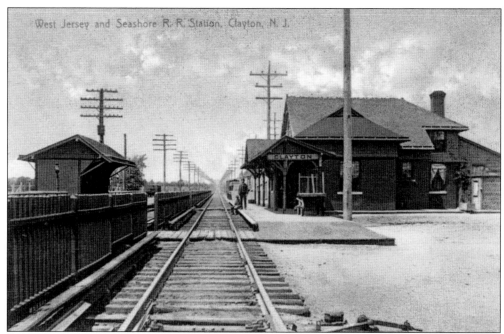

This is a photograph of the station looking north. Northbound trains would stop at Glassboro, Pitman, Sewell, Mantua, Wenonah, Woodbury Heights, Woodbury, Brooklawn, Gloucester, and Broadway Station in Camden, then proceeded to the end of the line, which was the ferry slip to Philadelphia.

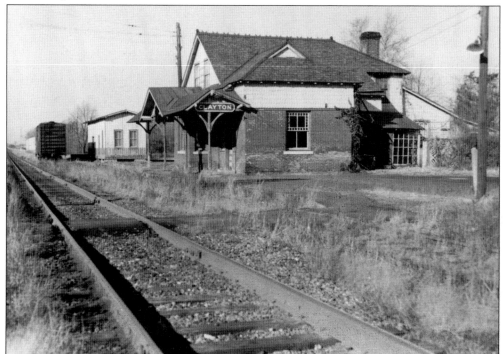

This picture shows the Clayton Railroad Station as it looked on January 14, 1962. It was operational from 1915 to 1968. The last passenger train travelled this route on January 31, 1971.

Five

LAKES

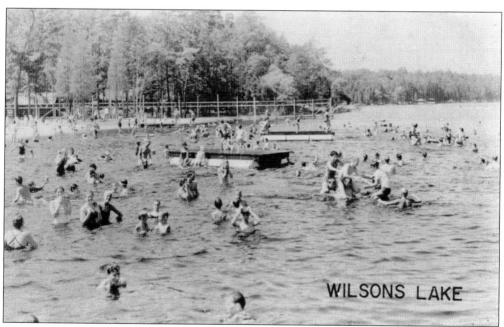

Approximately 3 miles from the center of Clayton sits Wilson Lake, now Scotland Run Park. This lake is one of two within the borders of Clayton. During winter, the lake provides a place to ice skate, play hockey, and ice fish. Every summer, when the end of the school year neared, the population of the lake area swelled, as shown in this postcard.

In this 1927 photograph is Mae Wilson. Like many people at the time, she placed this picture inside Christmas cards that she sent during the holiday season. The Wilson family owned a 900-acre piece of land that included the lake. At one time the lake was called Fries Mill Lake—named after a nearby mill—but in time the name changed as its new owners became associated with the lake area.

This photograph of Seymour Wilson was printed as a postcard. Seymour was a brother of Mae, and he helped build the accommodations around Wilson Lake with his brother George. In addition to the lake, the Wilson family also owned a number of orchards on their property. One local story is that old man Wilson, the father, took a load of crops to Philadelphia to sell. As the story goes, the horse and wagon found their way back home, but the father never did. Recently a letter was discovered that was written to Mae Wilson, sent from Texas, and was simply signed "Daddy." Perhaps the father leaving his family led to Mae, Seymour, and George never marrying.

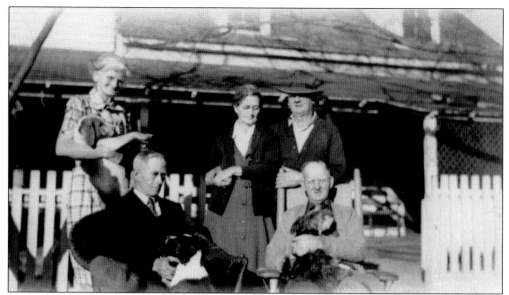

This photograph was taken in front of the Wilson home. In the back left is Mae Wilson holding one of the family dogs. Seymour Wilson is standing on the far right, and George Wilson is sitting directly in front of him.

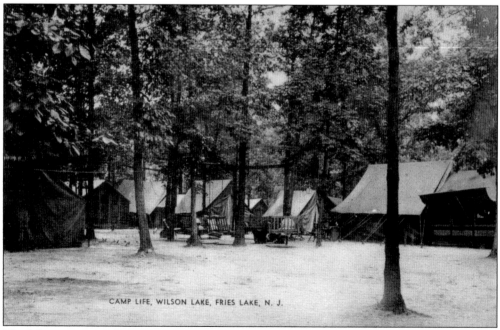

CAMP LIFE, WILSON LAKE, FRIES LAKE, N. J.

The lake was primarily a summer retreat for families around south Jersey and the Philadelphia area. As seen in this postcard, the rentals were nothing more than wooden frames with canvas coverings, but the rustic living quarters did not stop people from enjoying their stays.

The Wilson house, pictured here in the 1970s, was located next to the lake. The Fries family was the first to own the lake. A dam was built to create it and the water was used to power the Fries' sawmill. At one time, Academy Street was referred as "the road to Fries Mill."

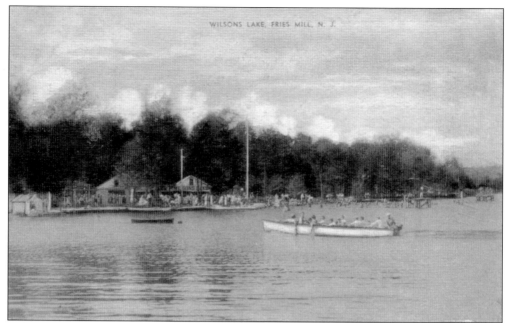

Each year when spring rolled around, so did the most anticipated event of the season: the arrival of Rex and Ruby Johnson. The Johnsons leased the lake from the Wilsons every summer and, as seen in this postcard, it was filled with locals and people from all over south Jersey. They would sell refreshments for those who visited the lake and would regularly hold dances. A hot air balloon launched by Ray himself would always draw a crowd. The Johnsons provided summer jobs for many Clayton teens that worked to prepare for the summer and maintained the grounds throughout the busy season.

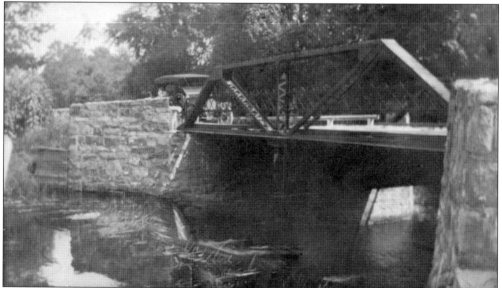

In this photograph is Fries Mill dam. Often mispronounced like French "fries," the actual pronunciation is "Freeze" Mill. The stream that runs there is Scotland Run. Before the Wilsons owned the land, the lake was called Fries Mill Pond while the Fries family owned and operated a mill there.

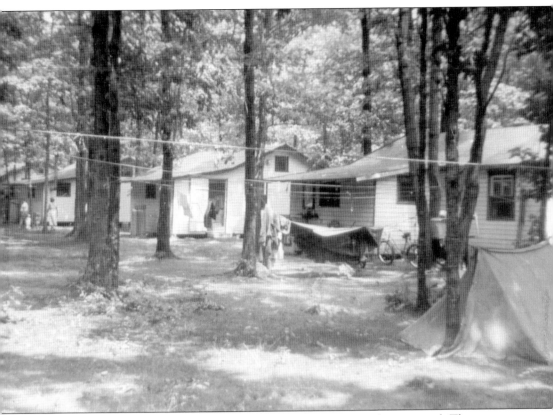

As years passed, George and Seymour Wilson built cabins, seen in this postcard. They were designed as summer rentals with no indoor plumbing. Some renters convinced the Wilsons to allow updates to the cabins that would make them suitable for year-round living. A community of permanent inhabitants was established as 10 to 15 residents became like extended family to the Wilsons.

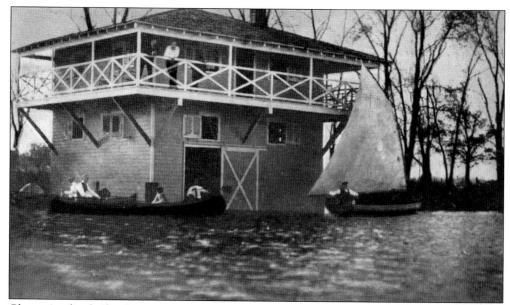

Clayton's other body of water was at one time called Harding Pond and later Moore's Lake before it received its most notable name—Silver Lake—in 1917. While it was owned by the Moore family, John Moore formed the Still Run Boat Club as a place where local bachelors and businessmen could meet. In 1907, a clubhouse was built, seen in this photograph.

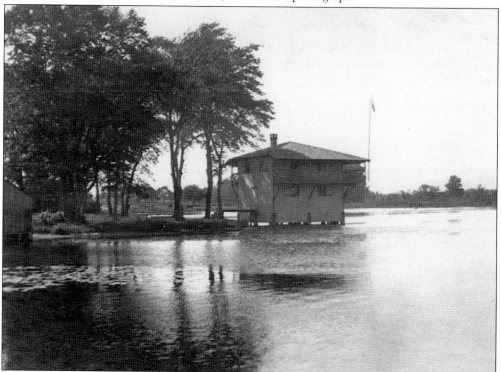

Pictured here in the 1930s, the boathouse was eventually owned by private residents. In the 1940s, it was owned by the Streitz family and was a popular hangout for kids who enjoyed swimming, canoeing, and fishing with the Streitz children.

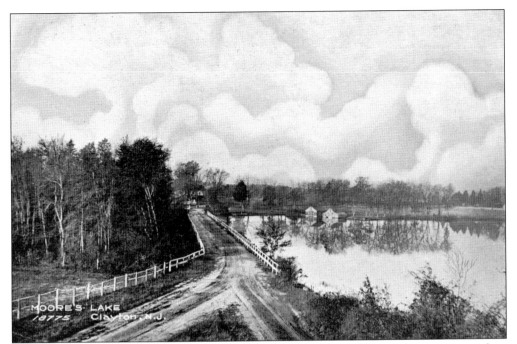

This is a postcard of Moore's Lake before the boathouse was built. During the summer, workers at the glassworks companies spent vacation time here since the factories couldn't operate because of the heat.

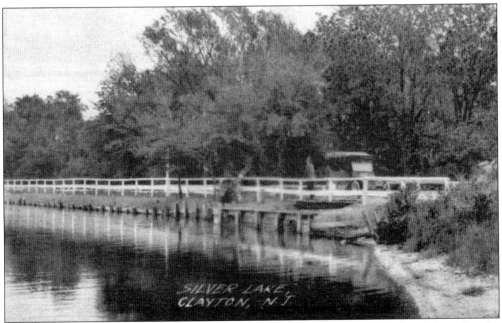

The wooden dam pictured here was eventually replaced. The lake was drained and cleaned under the supervision of Linton Silver, an employee of the Silver Chamberlin Brush Company, who bought the lake and the 50 dwellings along the shore in 1917.

Linton Silver's interest in the area first began when he was a child and the lake was the local swimming hole. After he purchased it in 1917, Silver oversaw maintenance of the body of water and formed an association to help with the lake's upkeep. On August 22, 1923, the association offered shares to its prospective members. Soon after, this once-unattractive pond was turned into a recreational paradise.

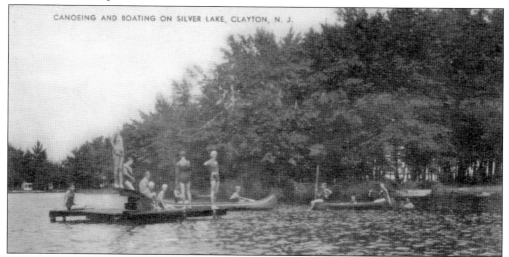

Postcards like the one pictured here sold throughout the community and surrounding areas, and the images printed on them typically showcased the lake, its shoreline homes, and recreational activities. During the Depression, some lake home owners were forced to rent their cottages. Over the years, many of the small homes around the lake have been rehabbed or replaced with beautiful new homes complete with all of the amenities of today.

Six

HOUSES OF WORSHIP

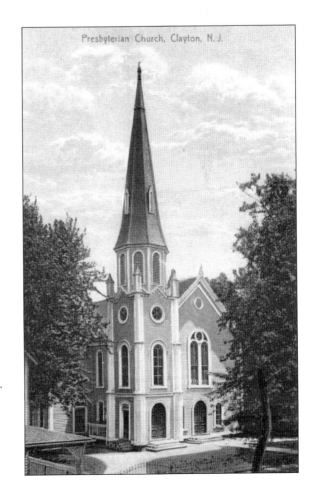

The First Presbyterian Church in Clayton was organized on August 18, 1853, with six members in attendance. Its original building was located at the corner of Center Street and Main Street and was used until 1868 when it was sold and used as a school. The Moore brothers donated the land on which the church was located.

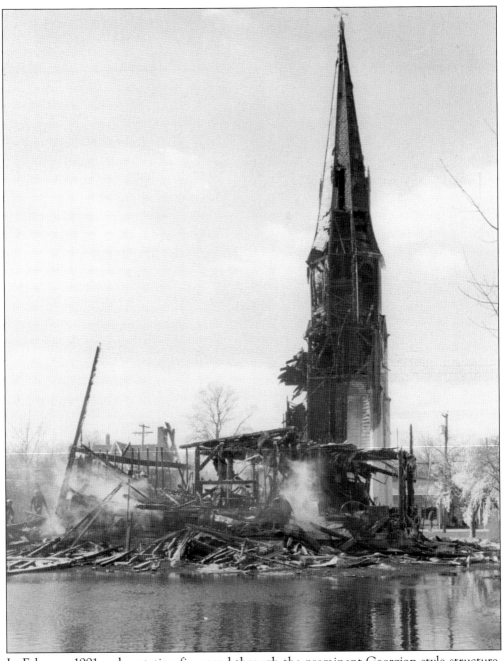

In February 1991, a devastating fire raged through the prominent Georgian-style structure, reducing it to a pile of rubble in a few short hours. The most recognizable piece left standing was the burnt shell of the bell tower.

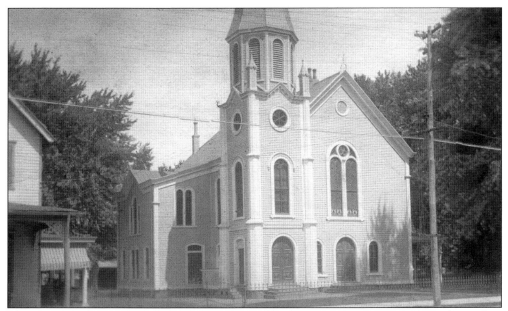

The church had a parsonage that was also donated by the Moore brothers, which was located on the northwest corner of Delsea Drive and Clayton Avenue. The original church building pictured here was constructed on an old brickyard in 1869 for $11,500.

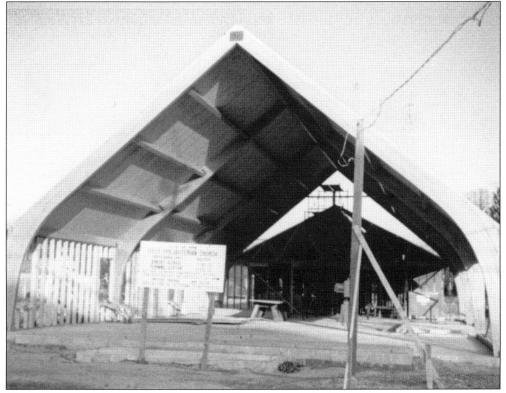

Almost immediately after the fire destroyed it, plans to rebuild the First Presbyterian Church began. It was never determined if the cause of the fire was arson.

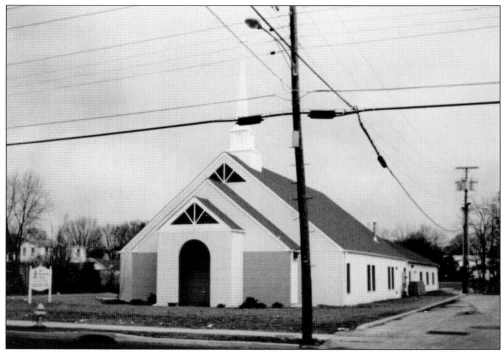

In May 1992, the new Presbyterian church was dedicated.

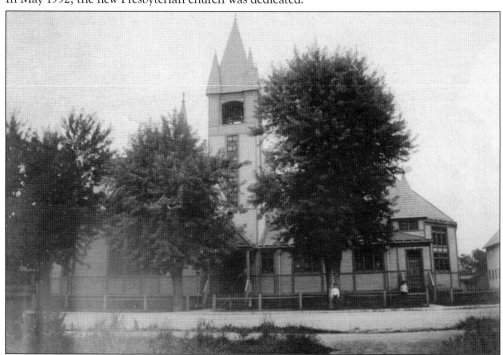

The Trinity United Methodist Church began in the home of John Early in 1770. In 1812, Jacob and Jane Fisler gifted 2 acres of land to be used for the location of the Useful School House, which was a school during the week and a church on Sundays. In 1853, the first church building was constructed for $5,000 on the land where the present church is located.

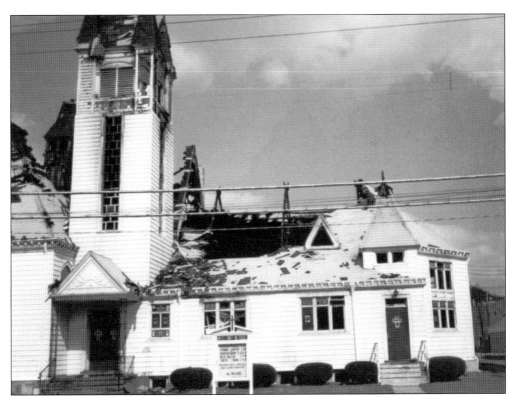

A fire destroyed the historic Methodist building in 1978, and a new church was erected and dedicated in 1981.

Located on Center Street, between New and Vine Streets, is the Praise Temple Church of God in Christ. The building sits on the south side of Haupt Field and started as a bakery. It was purchased from William and Rose Gravino in the 1930s, and the first pastor was William Buxton.

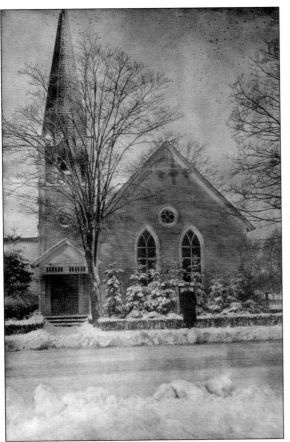

In this photograph is the original First Baptist Church of Clayton with Rev. Gordon Robertson standing in front of the sign. The church was incorporated in 1889 and this building was constructed in 1891 at its present location. The education wing was added in 1969 and the second addition was added in 1980, after the original building was torn down to make room for it.

On March 9, 1910, Addie Lee, George Bates, James Green, and David Butler, with the help of Rev. J. T. Plenty from Camden, organized St. Paul's Baptist Church. The church began in the home of Brother Butler until a small building was rented on the southwest corner of Academy and Union Streets. In 1914, a plot of land was purchased from Ruth Ann Stanger, and the building was rolled on logs across the street to its present location. The building has had a number of additions and is still a part of the current church, serving as the pastor's study trustee room.

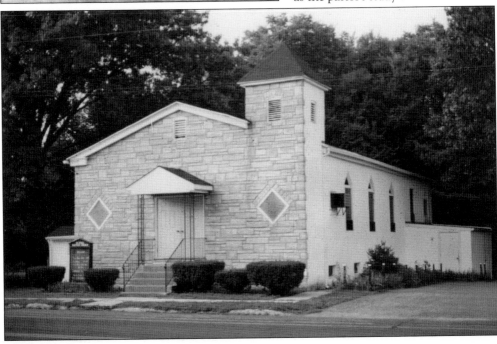

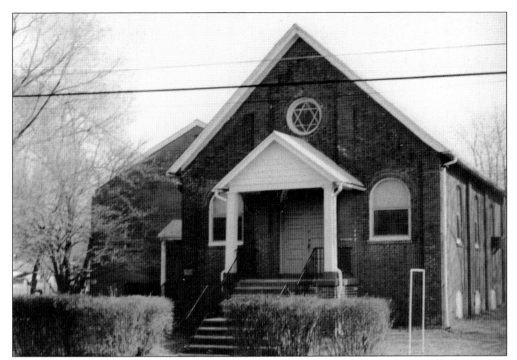

Around 1930, a group of Jewish men purchased the church on east Center Street, which was built in 1909. The building was used as a synagogue and an addition was added in 1956 that was used for dances, card parties, raffles, community breakfasts and dinners, and Hebrew school classes.

St. Catherine of Siena was organized in 1943 as a mission of St. Bridget Parish of Glassboro. The property on the southwest corner of North Street and Delsea Drive was purchased in 1944 and renovated into a chapel. The first mass there was celebrated on Christmas Eve in 1944. The property where the current church is located was purchased in 1946 from the Warrick family. Ground-breaking for the building in this picture was in 1951.

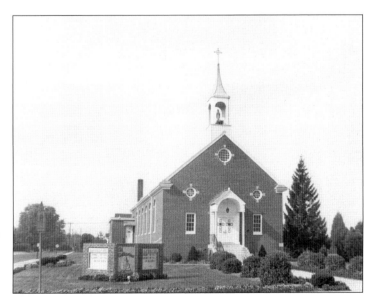

This house was originally located on Linden Street behind the original First Baptist Church. It was the home of Emma Moore, daughter of D. W. Moore. She was a teacher and later the principal at Clayton public schools. The structure was relocated to make way for the construction of a new sanctuary for the Baptist church. The house is now located on Walnut Street. House-moving was very common in the late 1800s and early 1900s. There are several homes in Clayton that were moved from their original positions to new locations.

Seven

MILITARY

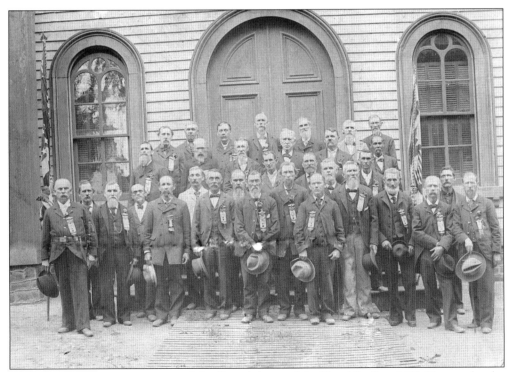

These Clayton citizens were part of the Grand Army of the Republic Sam Mills Post, under the leadership of commander Elwood Costill. The post was located on the southwest side of Pearl Street behind the present Acme building.

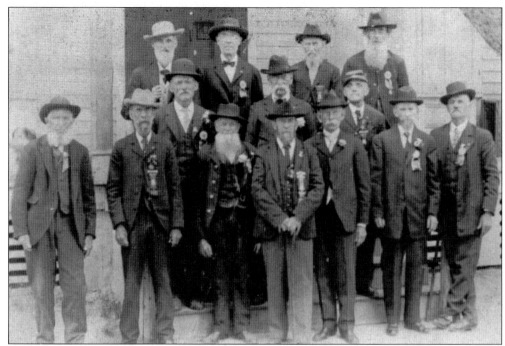

This photograph shows some of the same Sam Mills Post members later in life. At far right on the first row is Comdr. Elwood Costill, who was also the postmaster for Clayton.

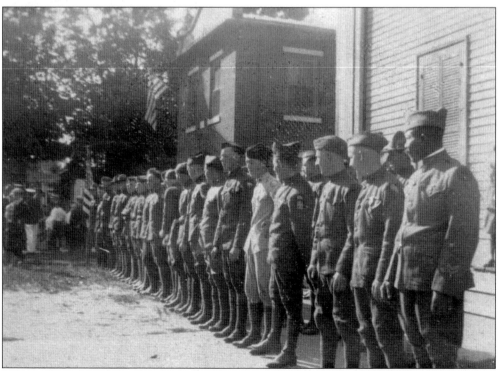

Taken on Memorial Day, this photograph shows soldiers lined up in front of the town hall and firehouse. This picture was taken sometime between World War I and World War II.

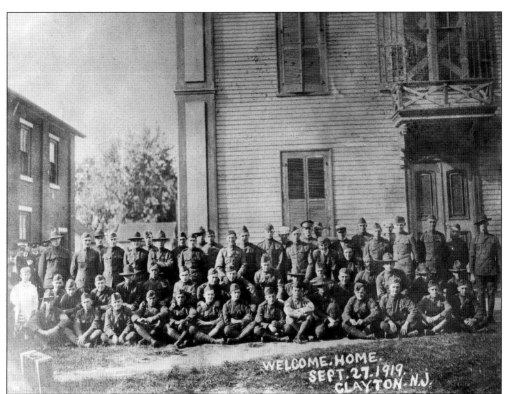

This photograph is of a welcome home celebration for Clayton residents who served in World War I. The event, which included a parade, was held on September 27, 1919.

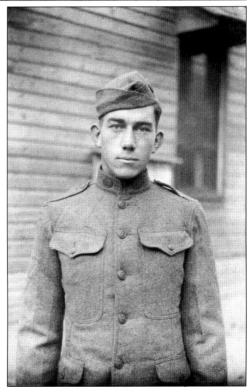

Joseph Roe Scott, known as "Uncle Roe" to his family, was born August 23, 1896. He served in World War I and is pictured here before his deployment.

Homer L. Ewan was one of the many young men who served their country and made the ultimate sacrifice. He was killed while serving in World War I. Clayton's American Legion Post 179 bears his name in his honor. The only other soldier from Clayton to die in World War I was W. Stout Cheeseman.

www.arcadiapublishing.com

Discover books about the town where you grew up, the cities where your friends and families live, the town where your parents met, or even that retirement spot you've been dreaming about. Our Web site provides history lovers with exclusive deals, advanced notification about new titles, e-mail alerts of author events, and much more.

MADE IN THE USA

Arcadia Publishing, the leading local history publisher in the United States, is committed to making history accessible and meaningful through publishing books that celebrate and preserve the heritage of America's people and places. Consistent with our mission to preserve history on a local level, this book was printed in South Carolina on American-made paper and manufactured entirely in the United States.

This book carries the accredited Forest Stewardship Council (FSC) label and is printed on 100 percent FSC-certified paper. Products carrying the FSC label are independently certified to assure consumers that they come from forests that are managed to meet the social, economic, and ecological needs of present and future generations.

FSC
Mixed Sources
Product group from well-managed forests and other controlled sources

Cert no. SW-COC-001530
www.fsc.org
© 1996 Forest Stewardship Council

Find Your Place in History.

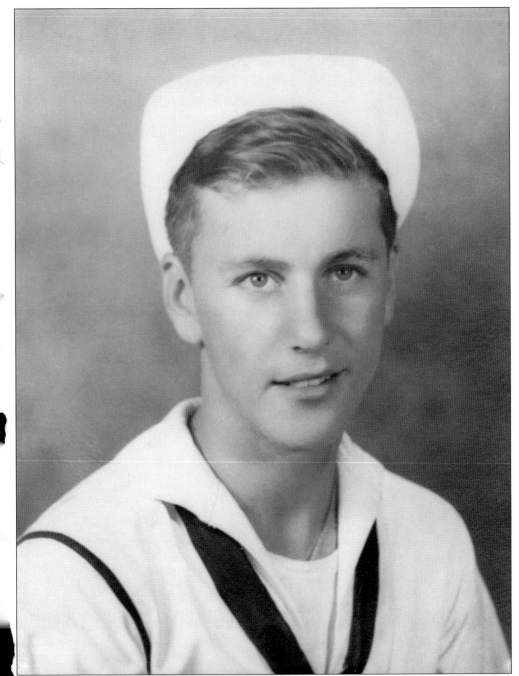

Gordon Jacobs was a member of the Clayton High School class of 1942 and, like many young men at the time, he volunteered to serve in World War II before graduating high school. Jacobs, pictured here at the age of 17, served in the U.S. Navy.

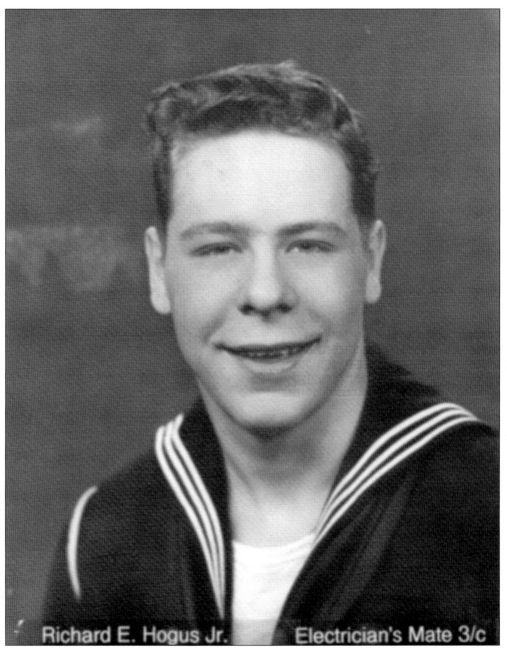

Richard E. Hogus Jr. Electrician's Mate 3/c

Richard E. Hogus Jr. entered the service in December 1942 as electrician's mate 3c aboard the USS *Underhill*. He participated in three Pacific engagements, including the Okinawa invasion. On July 24, 1945, he was killed in action off the Republic of Formosa (Taiwan) while serving aboard the destroyer. He was awarded the Purple Heart for his service.

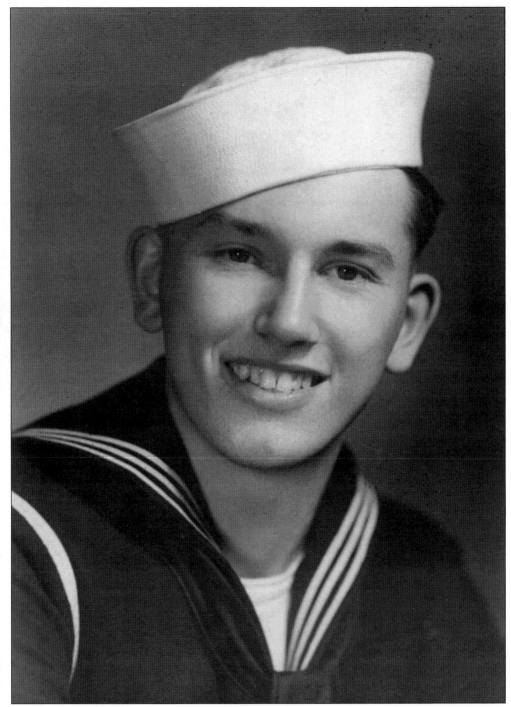

Harold "Brud" Costill was a member of the Clayton High School class of 1941. After graduation, and with his father's reluctant signature, Costill joined the U.S. Navy. He attended electrician's mate school in San Diego and afterward was assigned to serve aboard the USS *West Virginia*. He lost his life on the *West Virginia* during the Japanese attack on Pearl Harbor on December 7, 1941. He is listed as missing in action.

The Memorial Day parade has been a part of Clayton's history as far back as anyone can remember. The tradition continues today. At the time of this photograph, which was taken on Memorial Day 1937, parade participants would gather at town hall and school students were given a flag to carry. When the parade ended, they would return to town hall and be given an ice cream Dixie cup and be allowed to keep the flag as a thank you for being in the parade. A real treat in 1937.

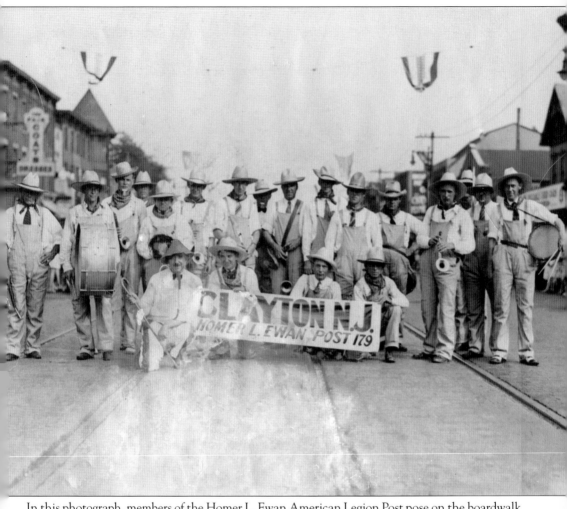

In this photograph, members of the Homer L. Ewan American Legion Post pose on the boardwalk at a convention in Atlantic City.